DAVID BELLAMY'S
Developing your
Watercolours

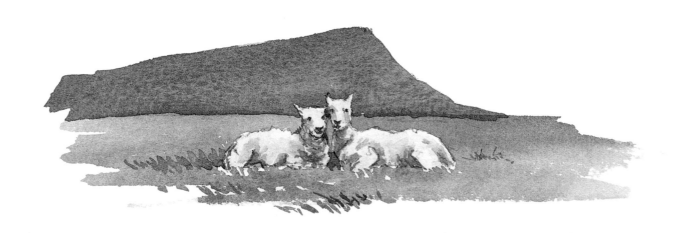

DAVID BELLAMY'S
Developing your
Watercolours

Collins

To my dear cousin Margaret, who was the first to steer me away from wallpaper and
direct the attentions of my brush to sketching paper

Acknowledgements

In producing this book I am indebted to Jenny Keal, who has moderated the wilder excesses of my manuscript, and
who took many of the photographs. I am also grateful for the expertise of
Cathy Gosling and Caroline Churton at HarperCollins,
and Caroline Hill, who designed the book.

A video, *Developing your Watercolours*, is also available. This and other videos on watercolour
painting by David Bellamy can be obtained from
APV Films, 6 Alexandra Square, Chipping Norton, Oxfordshire OX7 5HL
David Bellamy's website address is www. Davidbellamy. co. uk

First published in 1997
by HarperCollins Publishers, London

This edition first published in 2008 by
Collins, an imprint of
HarperCollins Publishers, London
77–85 Fulham Palace Road
Hammersmith
London W6 8JB

The Collins website address is www.collins.co.uk

11 10 09 08
1 3 5 7 9 10 8 6 4 2

© David Bellamy, 1997

A catalogue record for this book is available from the British Library

ISBN 13 : 9780007273454

Editor: Ian Kearey
Designer and Typesetter: Caroline Hill
Set in Goudy and Helvetica
Colour origination by Colourscan, Singapore
Printed and bound in China by Leo Paper

PAGE 1:
Two shorn sheep

PAGE 2:
PENNINE FARM
(detail)
305 x 485 mm
(12 x 19 in)

OPPOSITE:
**Cottage with abstract
foreground**

Contents

Introduction

Many people wonder if painting can actually be taught. 'Isn't it simply a matter of talent?' they ask. However much talent a person may possess, he or she needs to be taught at least the basic techniques, and this often takes some time to bear fruit. Hard work, determination and enthusiasm are essential ingredients to success. With perseverance you will one day find that suddenly a picture will really take off and stand out above the rest. This is often followed by less inspired works, until gradually you begin to see further progress. Most of all, keep trying: Cézanne once abandoned a portrait only after he had gone through over a hundred sittings with his model!

▶ COTTAGE AT BLAENAU FFESTINIOG
150 x 280 mm (6 x 11 in)
This cottage stands in a sea of discarded slate. Here, I have subdued the urge to paint in every slate, employing a lost-and-found technique, as demonstrated in Chapter 9, to suggest rather than put in everything.

The Importance of Drawing

The foundation of watercolour painting is the ability to draw, whether sketching in the initial image with a pencil, or drawing details with a fine-pointed brush. Practise your drawing at every opportunity, using a sketchbook. My own draughtsmanship improved immensely when I studied life drawing directly from the model, before beginning to paint in earnest. I cannot emphasize how important it is to continually strive to improve your drawing.

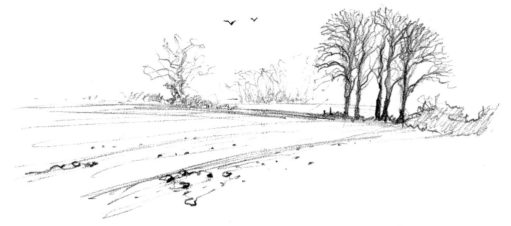

◀ **Field near Colwall, Herefordshire**
This kind of pencil sketch is invaluable not only as a note of a particular scene, but also as material for projects in the future.

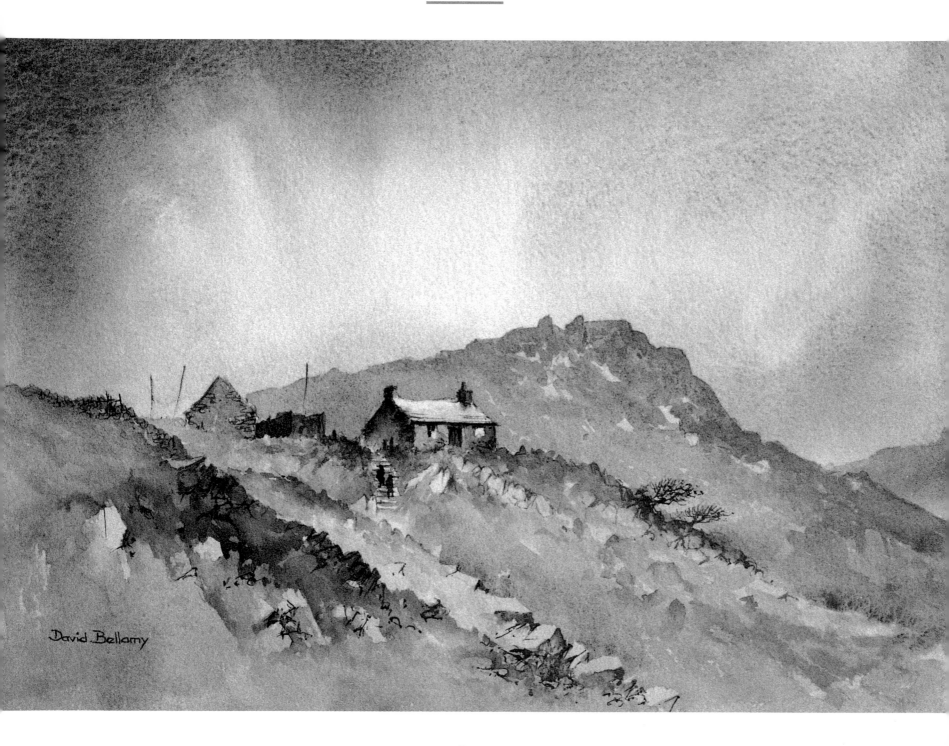

David Bellamy

Failed Paintings

Everyone experiences failures, and many tutors will tell you to scrap them. On the contrary, keep your minor setbacks (as perhaps they should be called), as even the most abject failure has a value. Put them away in a folder and take them out in a few months' time. They can serve a number of different purposes. Firstly, they provide a benchmark to your progress – 'Did I really paint that awful mish-mash of turgid patterns six months ago?' you ask yourself in disbelief. Progress may be hardly perceptible, and comparing your current work with that done some time ago is a salutary lesson.

The second reason for retaining your disasters is that you can use them in an experimental way, employing methods described in this book, to learn how to lay a glaze across an already painted area; how to breathe life into a failed painting with stronger contrast, colour and figures, among other methods; and how to add and take out features with a sponge. Finally, of course, as you gain experience you will become better able to correct the watercolour, or at least rescue a part and turn it into a smaller painting.

Using this Book

While the book assumes that you have some experience in watercolour painting, fundamental techniques are emphasized in appropriate places, to help both beginners and those with some experience who may be slightly unsure about basics. Even quite experienced students who attend watercolour courses can benefit from being shown some of the more fundamental techniques at times. With this in mind, you should aim to absorb the contents of each chapter thoroughly by repeating experiments with the techniques described before going on to the next.

'Gathering the Material' deals with materials and working out of doors in search of subjects (even though you may not wish to work outside). 'Giving your Paintings Impact' is concerned with constructing your paintings from source material, and helps you to transform your work into something more exciting, by improving the compositions with a variety of techniques, including using lighting to good effect.

▲ **The author sketching by his tent**

'More Exciting Techniques' explores atmosphere, colour and other fascinating techniques that will make your watercolours glow with power and rise above the ordinary. Many artists find it difficult to keep their work moving forward in the way they would like, and 'Progressing your Work' suggests lots of projects along the lines of the exercises in this book, which will set you goals, plus ideas for exhibiting your work. Finally, the 'Gallery of Paintings' shows my interpretations of the exercises. Try not to look at these until you have completed each exercise, as it will affect your execution of the painting. Your style has a greater chance to develop if you can restrain your curiosity.

In all painting, especially in watercolour, practice, experimentation and a willingness to take risks are essential. Being too tight or too inhibited will hamper your progress, so welcome your mistakes. You will probably learn more from them than when everything is working perfectly. At whatever level you work, watercolour is a gratifying vehicle for expressing yourself. According to Goethe, 'Every beginning is cheerful; the threshold is the place of expectation.'

▲ A sketching demonstration

◄ Cregneish, Isle of Man
Because the ground fell away at this side of the cottages, I sketched by viewing through a 200 mm camera lens from some distance.

Gathering the Material

This section begins with a look at suitable art materials and equipment, before going out with sketchbook to search for subject matter. Sketching can be the most joyous and free of all art-based activities, and there are some key aspects of sketching that will aid your paintings on all levels, be it from heightened observation or rapid note-taking from a train or bus. Whether you relish doing a full painting out of doors, or are wary of setting up your easel to perform in full view of the general public – and even if you could not be induced or even dragged outside to paint by the entire committee of the Royal Watercolour Society – you will find the techniques and ideas in this section of value in all aspects of your painting.

▶ FARM IN THE RHINOG MOUNTAINS
305 x 473 mm (12 x 18½ in)
Only four colours were used in this painting:
French Ultramarine, Burnt Umber, Raw Sienna and
a little Cadmium Red. The coldness of the distant
mountains is emphasized by the warmth of the
fields in the foreground.

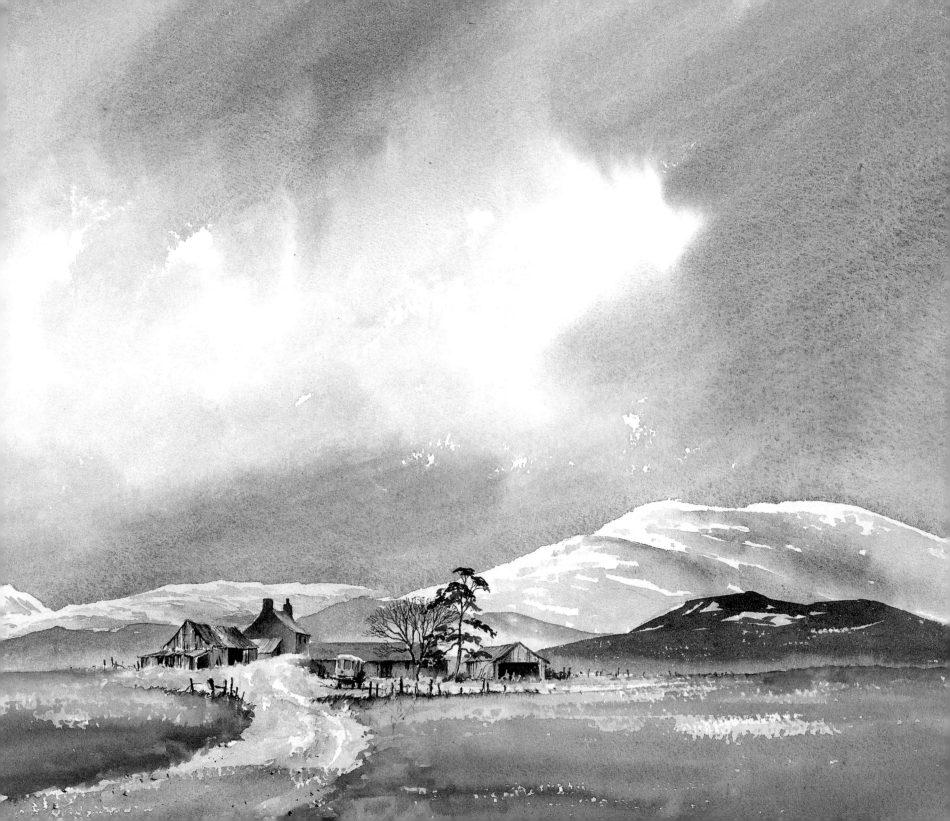

1 Materials and Equipment

Many inexperienced artists feel that if they get the 'right' brush, or that magic tube of paint, their work will automatically improve by leaps and bounds. Using first-class materials will certainly help, but in the end it is the development of painting skills which will push your work forward. The materials market is forever changing, but you should always aim to buy the best you can afford.

Brushes

Finding your way through the brush maze is demanding. What is the best brush for laying a wash? Are synthetic brushes as good as they claim? While sable brushes remain the best for watercolours, as is reflected in their high prices, their former advantages are slowly being eroded as technology improves the synthetic variety. Additionally, because of the high demand for sable, many brushes are now being produced with inferior hair, making their pointing quality poor. Test a sable in water to see if it points adequately before you part with your money; good art shops should allow you to do this.

Before you make a choice of brushes, however, you must define your needs. There are brushes for large washes, for medium-sized passages where some detail might also be desirable, for smaller areas of the painting, and for fine detail, and each demands different characteristics. How large a wash brush you need depends on the size of paper you work on: for a quarter-imperial sheet of 280 × 380 mm (11 × 15 in) a small mop or a 25 mm (1 in) flat brush will work reasonably well, but a larger brush would be sensible for a sheet of half-imperial paper of 380 × 785 mm (15 × 31 in). Naturally, if you use a variety of sizes, then the largest brush would be advisable, as this can also be used on smaller works.

In rendering many passages, there may be a need to lay a reasonably large wash with perhaps one or more smaller areas of detail within that passage, such as sheep in a field, crags breaking out of a mountain slope, or a complicated skyline. A large brush which points well and is capable of laying large washes and applying detail is a distinct advantage, as the actual act of changing brushes can cause problems as the wash begins to dry. Speed is of the essence, and a round synthetic brush from Nos. 12 to 20 is invaluable, as sables in these sizes can be prohibitively expensive.

A number of smaller round brushes – Nos. 4, 6, 8 and perhaps 10 – are necessary for smaller areas of working. This is where the best sables really score, and are well worth getting, although there are many excellent mixtures of 50 per cent sable and

▶ PEMBROKESHIRE FARM
180 x 355 mm (7 x 14 in)
The dark sky of Indigo makes the light-roofed building stand out, illustrating the importance of tone and contrast.

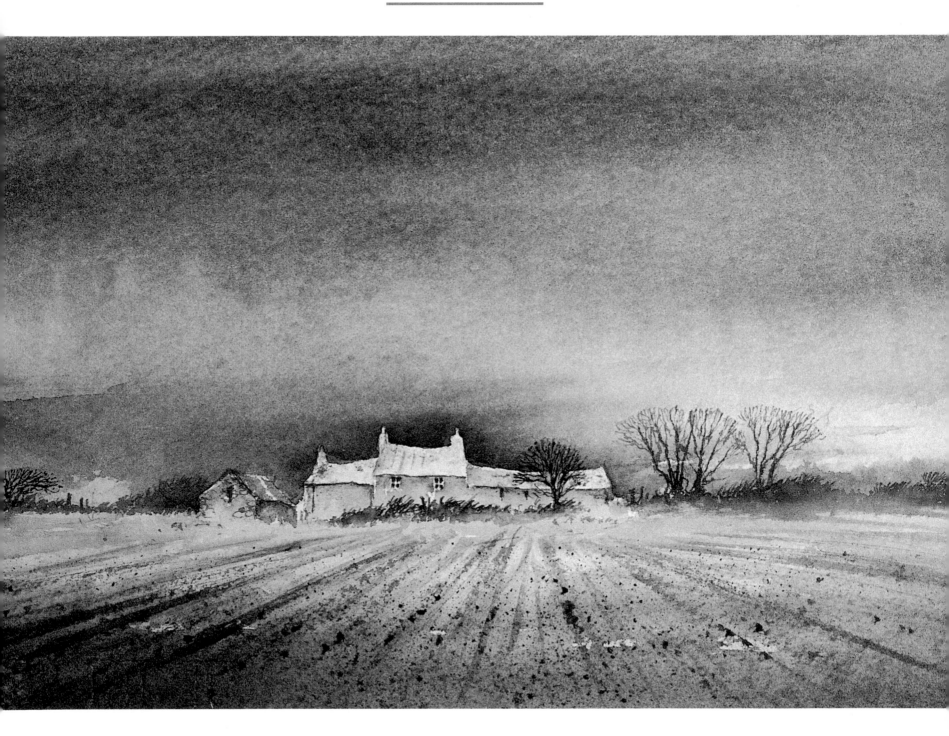

50 per cent synthetic-filament types available. So if you cannot afford a sable, go for a mixture in these sizes. Make sure they point well.

Some round brushes work well with the most delicate of details, and while I employ them in this way regularly, I also find a rigger brush, sometimes called a writer, indispensable. The rigger has longer hairs than normal and holds a lot of paint for a brush of its size. The fine filigree of winter branches can be delineated effectively with a No. 1 rigger. For certain situations a 13 mm (½ in) flat brush can also be useful.

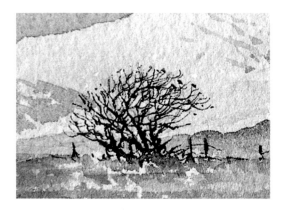

▲ FARM IN THE RHINOG MOUNTAINS (detail)
The fine detail was rendered with a No. 1 rigger brush.

Watercolour Paints

The paintings in this book employ a wide range of colours, although the range is deliberately restricted in any one painting. I steer clear of any fugitive colours, which fade badly after a period. Information on colour fastness and opacity is normally given on the colour charts issued by the paint manufacturers.

Should you use artists' or students' grade paints? Student-quality pigments are cheaper, but some contain colour substitutes and are less finely ground than the artists' variety. My own feeling is that once you start selling your paintings regularly, it is then worth while using only the better quality paints. However, if you are happy with the extra cost, it does pay to use artist-quality paints from the start.

Pans or tubes? I find pans too fiddly for large washes, and enjoy the lovely moist colours that are squeezed out of the tube. There is probably less wastage with pans, and they are particularly convenient for working out of doors, whether painting or sketching. However, there is a temptation to dip into a multitude of colours when using pans, and this can be detrimental to the unity of the work.

Colours of the same name vary to a degree with different manufacturers, but this should not be a problem. Those starting off in watercolour are best advised not to buy a huge range of paints; it is much better to buy about eight or so of the more useful colours and get to know their characteristics thoroughly before adding to the range one by one. Too many at once

will simply confuse. My most used colours, from the Daler-Rowney range, are French Ultramarine, Raw Sienna, Burnt Sienna, Burnt Umber, Cadmium Yellow Pale, Cadmium Red, Naples Yellow, Cobalt Blue, Indigo and Light Red.

Watercolour Paper

Choice of paper is critical to the quality of the final painting. You will discover your own preferences for paper once you are aware of the characteristics of each type; here I begin to guide you through the maze in choosing a paper that is sympathetic to your own individual needs.

Watercolour paper comes in a variety of sizes, forms, weights and surfaces. In its simplest form it comes in sheets, which are generally imperial-sized (approximately 560 × 760 mm or 22 × 30 in); this is normally the cheapest way to buy paper. Many manufacturers market pochettes

▲ **Watercolour paper in pochettes**
This is an excellent way to try out a variety of papers.

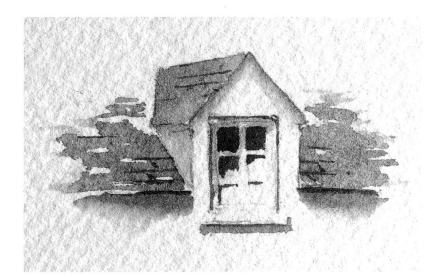

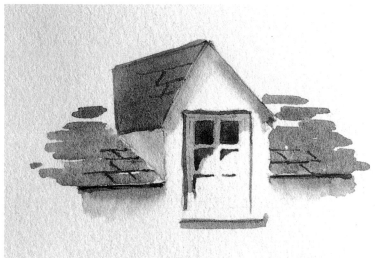

▲ **Detail on Rough paper** (above left)
Detail on Hot Pressed paper (above)
Note how sharp the image is on HP paper.

containing a sheet of each weight and surface they make. These pochettes are roughly 305 × 405 mm (12 × 16 in) and are an excellent way of becoming familiar with the different papers available. Pads are useful for working out of doors, and many artists use them all the time, although they are a more expensive way of buying paper. Blocks avoid the need to stretch paper by having binding all round the edges, but they are correspondingly more costly. Watercolour boards are yet another way of working, but they take up more room, need a frame with a deeper rebate, and again are costly.

The most common weights of paper are 180 gsm (90 lb), 300 gsm (140 lb), 410 gsm (200 lb) and 600 gsm (300 lb); they are nearly always sold in their imperial weights. The 180 gsm (90 lb) paper is excellent for watercolour sketches but cockles easily, so it definitely needs stretching. When using the 300 gsm (140 lb) weight, which is the most

popular, if you work larger than about 255 × 355 mm (10 × 14 in), or if you use copious amounts of water in your washes, it will normally need to be stretched. A good compromise for those who hate stretching paper is to purchase your favourite surface in a 410 gsm (200 lb) weight.

Most artists find the Not surface suits them best. Not means Not Hot Pressed (known as Cold Pressed in the USA). Most Not surfaces have a pleasing degree of roughness without being too smooth, and take washes and detail well. The Rough surface, being slightly rougher than Not, is not quite so good for detail work, but is superb for certain techniques, such as applying paint with the side of a brush to produce a textured finish. The HP, or Hot Pressed surface, is entirely smooth and excellent for fine detail, but it is quite unforgiving if you get your washes wrong. HP is a particularly good choice for pen and wash work.

▲ Dry-brush effect on Rough paper
Rough paper works best when dragging a brush
quickly across an area, using hardly any water.

▲ Dry-brush on Not paper
The dry-brush technique also works reasonably
well on a Not surface.

▲ Dry-brush on Hot Pressed paper
Attempting the dry-brush technique on HP paper is
pretty hopeless, as the surface is so smooth.

One manufacturer's Not can be
different from another's, both in degree of
roughness and surface texture. This applies
to all types of surface, and is really a
question of individual preference. I dislike
the more mechanical and regular-looking
surfaces. The degree of sizing also affects
the absorbency and strength of the paper,
which is why some papers are more
absorbent than others, and why some are
fragile and cannot take much sponging or
even rubbing with an eraser. Saunders
Waterford, for example, is both internally
and externally sized, resulting in an
extremely robust paper that is tolerant of
my mistakes and subsequent corrections.
All the paintings in this book were
painted on Waterford, except a few on
Bockingford; the latter are specified in the
appropriate captions.

Care of Paper

A slight mark or score across a sheet of
watercolour paper can ruin a painting, and
you sometimes only see the offending
mark when it is too late. I try to cover as
much of the paper with a wash as early in
the painting as possible, so that any
problems show up immediately; this way,
not too much time and effort has been
wasted. The secret, however, is to reduce
the chances of damage to the paper.

Never finger watercolour paper, either
in the shop or at home. Sadly, given the
opportunity, many customers will handle
the paper, causing dirty marks, tears or
scratches, some of which are not visible
when you buy. If you buy several sheets at

a time, they are better protected and less prone to damage. Handle them only by their extreme edges, and wash your hands before working with the paper – hand creams, oils and modern cosmetics can badly affect the surface, creating a resist to the watercolour. It is easy to blame the manufacturer when more likely the method of handling is at fault.

Palettes

There is a bewildering range of palettes for the watercolourist, so where do you start? Some artists swear by various items found in supermarket kitchenware departments, or a humble white saucer. I generally use a white butcher's tray for studio work, with individual china mixing wells for the main washes, and a variety of palettes for outdoor use, depending on the type of trip. Deep mixing wells are essential for producing copious amounts of liquid colour. I prefer the round ones, as colour is difficult to remove from corners.

Other Studio Items

One or two drawing boards are necessary. Natural sponges, some 3B or 4B pencils, a putty eraser, large water pot, gummed tape (for stretching paper) and masking fluid (for masking out small areas to keep them white), are also valuable materials which will be discussed later. Some water-colourists like to work with table easels, but a pile of books can be just as effective in keeping your board at the right angle for painting.

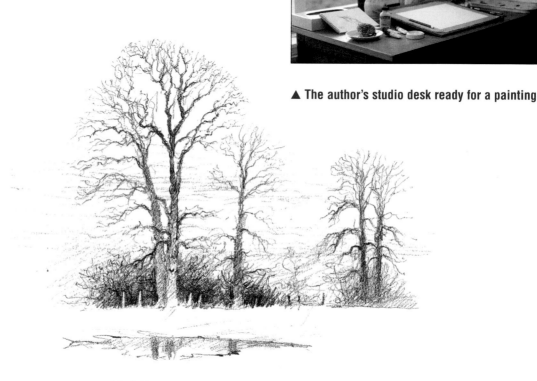

▲ **The author's studio desk ready for a painting**

Lighting

There are occasions when the light is so appalling that it is impossible to work without artificial light. However, the warm colour cast of ordinary lights can create a false sense of colour. I use an adjustable lamp with two daylight-simulation fluorescent tubes, which are made by Daylight Studios.

▲ **Trees at Bramshaw, Hampshire**
This sketch was carried out from the comfort of an armchair, looking out of a window.

2 Sketching on Location

Sketching is fundamental to painting, and will free you from the shackles that hinder development. Jenny, my partner, confesses that in the 10 years before we met she filled only one sketchbook! Now her sketchbooks are piling up rapidly towards the ceiling. Many students on my courses sketch for the first time in their lives, despite having painted for years. Reasons for not sketching range from being afraid of artistic onlookers, concern for safety, possibility of bad weather, possibility of good weather, wild animals like sheep and cows, lack of toilet or refreshment facilities, to being out of touch with the news. With such a wide range of nasties lurking in the countryside or seaside, why should you subject yourself to them?

Working directly from nature with pencil, pen, brush or whatever medium you wish to use, will advance your work infinitely more than sitting in a classroom, reading a book or watching a video. All these help, but none so much as observing how varying light conditions affect the subject, how juxtaposing colours can intensify those colours, how comparing tones brings your work to life, and so on. You need not go far in search of subjects. Here, I will concentrate on the more readily accessible options; for those who wish to sketch in remote and wild places I would refer you to my book *Painting in the Wild*.

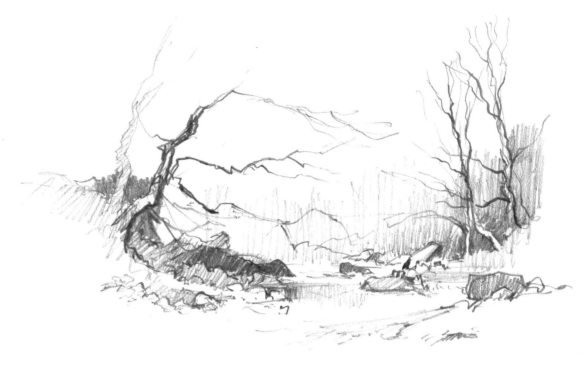

Observation

Before you begin sketching, consider how you observe things. By this I do not mean simply looking at objects and recognizing them as a gate or a horse, but seriously looking at features in a considered way, in order to ascertain how that feature sits in the landscape, how it relates to the surrounding objects, how the light affects it, and how distance modifies its colour and detail as you move closer or further away. You can practise increasing your powers of observation everywhere: as you

▲ River Clydach near Dan y Coed
This five-minute pencil sketch was done while waiting for a television crew to film the river. Always have a sketchbook handy.

▶ Woodbridge Tide Mill
Watercolour sketch on cartridge paper.

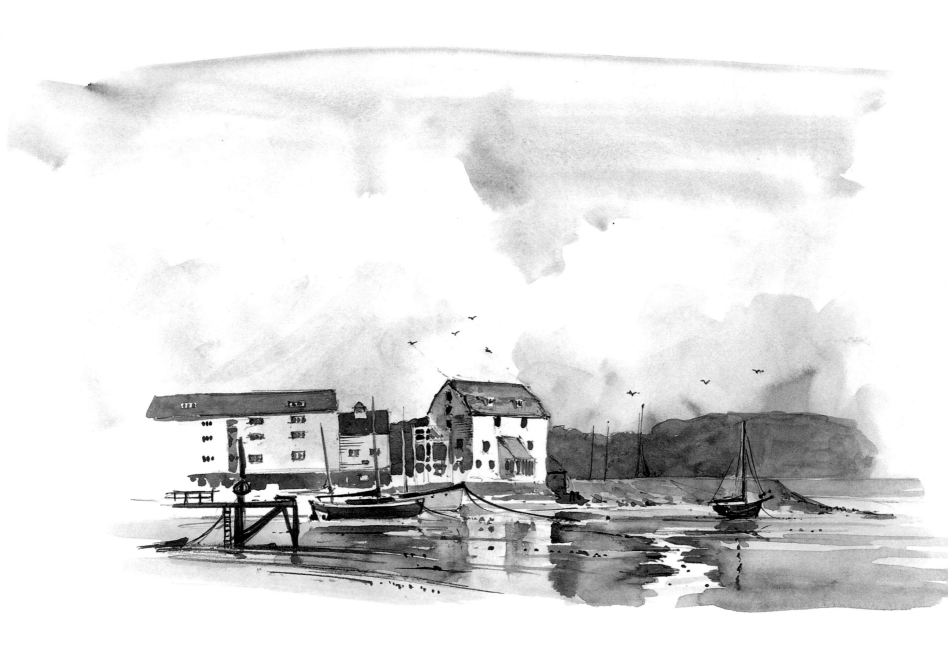

walk, ride on a bus or when you are stopped at roadworks, at home, or whenever you please.

Learn to really look at and analyse objects. Compare tones and the degree of darkness or lightness of an object: for example, is that roof lighter or darker than the trees behind? How is it affected when the sun comes out? In an intricate building compare the sizes of the various parts, ask yourself why you cannot understand how a certain feature works, and move in closer to examine the problem.

Observation is also exciting: when low evening light casts the shadows of a hanging plant onto the plain white surface of the freezer, I find myself analysing the quality of the cast shadow – are the edges soft or hard? How soft? Such consideration

▲ Simple sketching kit
A few brushes, pencils, a watercolour box, a cartridge pad and a watercolour pad fit quite well into a large waist bag. I protect my sketchbooks with a waterproof cover.

sticks in the mind and truly helps your sketching and painting.

Studies with a Pencil

It is an easy step to working with a pencil and small sketchpad of cartridge paper. A good-quality pad about A5 size, plus a few 2B, 3B or 4B pencils, finely sharpened, are all that is necessary to begin. Forget about the vast panoramas for the moment and concentrate on drawing a gate, for instance, or a barn. Build up a reservoir of material for use in paintings. Such studies can be done in the back yard, in the house or even from found objects, such as broken twigs, rocks or discarded fence posts. The studies should include tone as well as colour notes on the side.

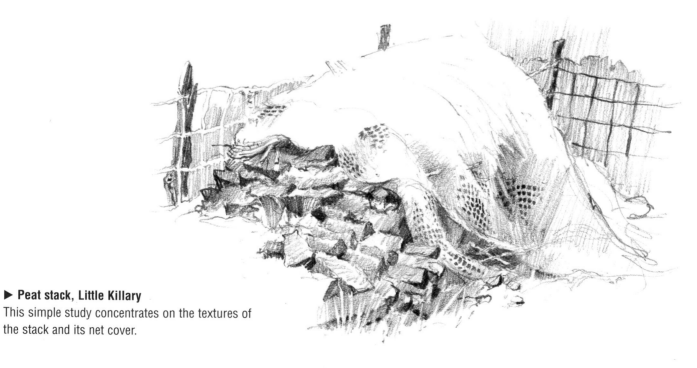

▶ Peat stack, Little Killary
This simple study concentrates on the textures of the stack and its net cover.

▼ New Quay, Ceredigion
Watercolour sketching can be a rapid way of rendering a scene where atmosphere is critical to the composition, or where colour is needed. I often combine loose watercolour washes in sketch form by drawing into the still-wet washes with darker watercolour pencils.

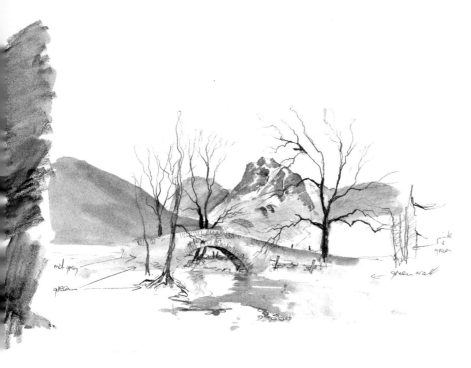

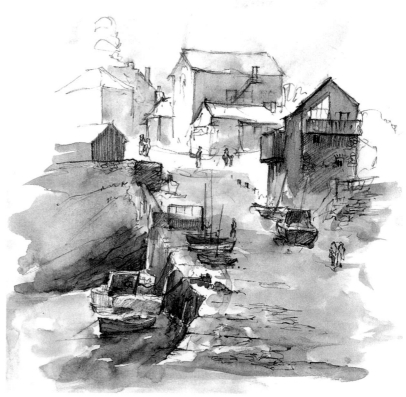

▲ Langdale Pikes and Great Langdale Beck
Whether used wet or dry, the Berol Karisma water-soluble pencils work extremely well when sketching. In this sketch I made the drawing first, then laid tonal areas on the left-hand side of the paper, picking them up with a wet brush and then applying them to the sketch. This method can introduce lovely atmospheric effects into your pencil work.

In addition, when sketching I use watercolour pencils, water-soluble graphite pencils, and carbon pencils with their lovely expressive blackness. Conté crayons and charcoal sticks are easy to carry around and are very effective for rapid, broad sketches, especially where rendering tone is vital and detail is less important.

Sketching a Scene

Most landscape artists are eager to get to work on larger compositions as soon as possible. Moving on to the larger, more expansive view brings with it many potential pitfalls. 'When faced with such a distractingly complicated scene, I must first of all choose a typical incident and define my picture, as if I could already see it framed,' was Manet's response to an intricate subject. Do you sketch what you see, or do you leave things out? What can you put in its place if you leave it out? One thing is certain: you will rarely find the perfect subject with everything exactly as you want it.

Some modification is nearly always needed. Farms, for instance, can make superb subjects when set in their environment, but are often surrounded by enormous black plastic bags of silage, dilapidated caravans, gleaming modern farming implements or massive ugly sheds. Taking out unwelcome contrivances means that you have to put something in their place, and it is here that the studies you have been making come into their own. A study of a rusting old mowing machine sticking out of long grass could replace the black bags, and the caravans could be substituted with a rustic old barn.

When you first come upon a subject, spend a few minutes considering your approach. What is the best angle? What is the optimum distance? Do you need to carry out more than one sketch or study from different positions? Although the building may look marvellous from a distance, set in a beautiful environment, you might need to close in to render intricate detail for use in a larger painting.

When sketching outdoors, it is wise to be aware of local characteristics. In Herefordshire, to give one example, there is a preponderance of red-bricked and wood-framed buildings, many of which possess chimneys that appear to have been

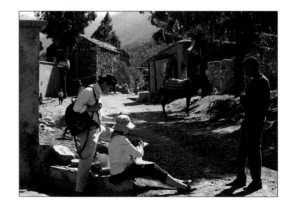

◀ **Sketching instruction in the High Atlas**

▲ **Farm near Tretio, Pembrokeshire**
A rough four-minute sketch of an area that is familiar to me, so that I can happily fill in the colours from memory. The quality and time taken on a sketch does not necessarily correspond to the quality of the finished painting.

◀ River Deben, Suffolk
A simple watercolour sketch made on a Bockingford pad, with an effective dry-brush passage on the water.

added as an afterthought. Including such features in a sketch or painting helps to bring out the individuality of the subject.

Drawing Techniques

The first consideration when sketching should be 'What is the centre of interest?' It might be a lone tree, a building, a waterfall, a sunlit sward of grass seen through a gateway, or anything that excites your eye. How large should it be on the paper? What other features must be included? A light pencil drawing beginning with the centre of interest helps to establish positions of various features as well as sizes, and can easily be adjusted if the first effort is not right.

Once the main features are positioned to your satisfaction, use stronger lines. I prefer to concentrate on those items that interest me most to begin with, particularly if there is a possibility of losing the light, a cartload of bananas about to block the view, or other such problems. Where sunshine is intermittent give the light priority, leaving any passage you are working on to concentrate on the lighting and shadow effects when the sun appears. Because shadows are forever changing, try to carry out all the features that may be affected at one go. Little looks worse than shadows that fly off in all directions!

Having to work rapidly in this way is excellent practice, as it teaches you to seek out and register the important features. If all the windows are the same, why waste time detailing them all in? Simply render the most prominent and outline the rest. The same applies to masses of trees. I generally pick out a couple of the finest examples of the trees and sketch them in more detail than the rest, which are just suggested in outline, perhaps with a small amount of shading.

▲ Active interest
Jenny often demonstrates to complete beginners on my courses.

Sketching Figures and Animals

There seems to be a natural reluctance amongst landscape students to include any living form in a work, yet a figure or animal can bring a painting to life. Most people, if they realize what you are up to, tend to be flattered that you are sketching them, and it is only occasionally that you will run into awkward customers. Take care overseas, however, as cultural differences may mean that some people will be unhappy about being drawn.

In a landscape painting it is unlikely that the figure or animal will be dominant. Close studies are therefore rarely needed (although any sketching is useful, of course). The attitude of the subject and how it relates to its surroundings are what matters more than a likeness. The best renderings are where the figure is engrossed in some activity, such as fishing, chatting in a street or climbing a ladder. Animals can be vital in providing a sense of scale in places where little else gives a clue, such as up mountains or beside crags.

Keep figures and animals simple. When drawing or painting groups, let individual forms merge into one another. Make sure there is nothing happening directly behind a figure or animal, or in close proximity on either side, or it will become lost in the mass of detail. Any doors and windows in a street scene should be left out if they come anywhere near the figure.

▲ A seated figure in Marrakesh with parasol

◄ Two shorn sheep looking rather alarmed

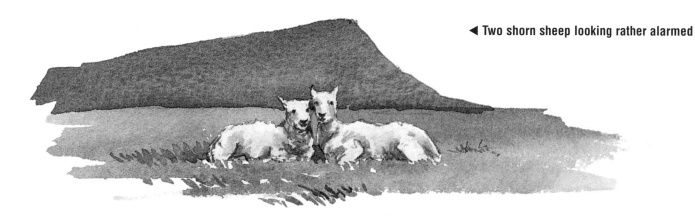

Photography

One question that always arises amongst amateur painters is that of using a camera. 'Is it allowed?' some ask, as though it is a great sin. As just about every professional artist uses a camera in some way, I hardly think students have cause to fear. Photographs are convenient and usually quicker than sketching, but if copied too precisely can lead to stiff, wooden paintings. I prefer to use the camera as a back-up to my sketches.

Work only from your own photographs, where you have actually been to the scene and at least have a idea of the character of the place. While you are at the location, try to foresee problems of working up the subject from the photograph. A quick explanatory diagram sometimes helps. Take several shots from slightly different angles, especially with an outstanding or complicated subject. By comparing photographs later you can often clarify potential points of confusion.

Enjoying Your Sketching

Sketching is usually the most pleasurable part of my work. Even in adverse conditions when rain is lashing down, I still get a buzz from it. The response is spontaneous, allowing more freedom than when painting in the studio. You can experiment, leave things out, leave the sketch unfinished, or whatever takes your fancy, and no-one has to see your results. It is your own personal statement, so go out and enjoy your sketching.

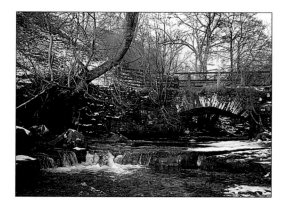

◀ Bridge in Swaledale, Yorkshire
When taking photographs of possible subjects, take a number of different views before choosing the one best suited to your purpose.

▼ Bridge in Swaledale, Yorkshire
By comparing this sketch to the photograph, you can see that I have left out much of the background to concentrate on the focal point, the bridge.

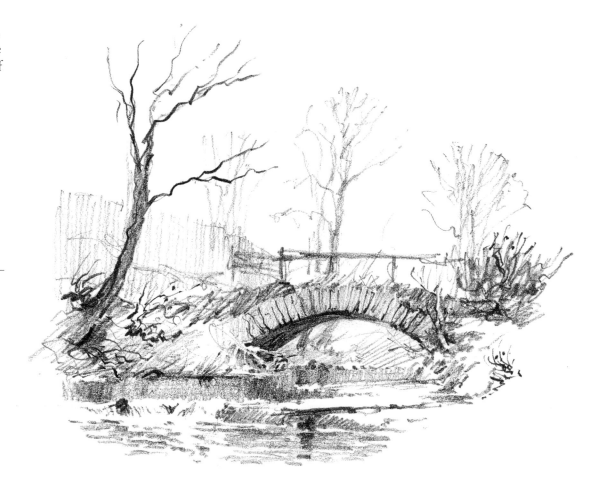

3 Painting on Location

The disadvantages of doing a full water-colour painting out of doors can easily appear to outweigh the benefits. There is so much more equipment to carry than when simply sketching, and sitting at an easel makes one feel vulnerable. The light and conditions can change drastically over the period it takes to carry out a painting. The weather could turn nasty, completely wrecking your watercolour after hours of hard work. Coastal subjects can prove difficult, with the changing tide making a considerable difference. So why bother with painting on location?

Technically, there really is only one reason for painting outdoors, and that is because the work has greater spontaneity. Paintings seem to come alive when compared to those done indoors. I carry

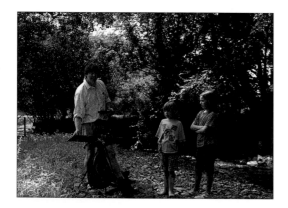

▲ **Painting by the River Cledlyn**

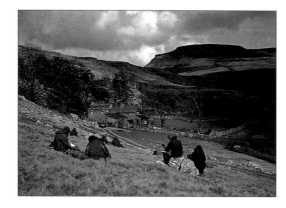

out few complete alfresco paintings, preferring to do watercolour sketches; when working from those watercolour sketches, it is a challenge to recapture the vibrancy of the original work. Watercolour sketching, by the way, is an excellent transition between working solely with a pencil and doing a full painting.

The only time that many students paint out of doors is during a course or if their local art society arranges a painting excursion – some join courses for that specific reason. There is a considerable gulf between the bravado of setting up with easel, paints and all the paraphernalia of the watercolourist, and simply working quietly with a small sketchbook and pencil. You are fair game to all those inquisitive passers-by, many of whom appear to be armchair artists themselves. How do you cope?

◄ **Students painting below Ingleborough**

▶ STONE BRIDGE AT RHYDDLAN, CEREDIGION
200 x 255 mm (8 x 10 in)
I set up the easel on a dry spot in the river bed, and was quickly surrounded by children who had been catching tiddlers nearby (see photograph left). Before long they were all sketching the bridge and had forgotten the tiddlers. I was mainly concerned with the light-and-shade areas on the river, and how the stonework appeared in places and became lost under moss in others. As usual, I left a wide margin on the right-hand side of the paper to quickly capture a figure or two – this is also useful for testing a colour.

Big Hats and Wild Ways

I find a big hat helps enormously and seems to keep people at a distance. I once wore an enormous sombrero when sketching in the Alhambra in Granada, and it gave me a tremendous feeling of confidence. Constantly flick paint all over the place: this will ensure that artistic onlookers keep their distance. A number of artists swear by a huge fishing umbrella, but of course this is an extra encumbrance and is certainly not appreciated in most high streets. The more eccentric you appear, the wider berth you will generally be given.

Most of the time, however, people say nice things about your painting, even to the point of offering to buy it, especially if you happen to be in a tourist area. Some artists find it propitious to have a whole series of almost-finished works in their folder, ready to be 'just finishing one off' when the next tourist appears! Once you have tried painting alfresco a few times you will probably feel better able to cope with the petty irritations that do occur from time to time.

▲ **Cottage near Kinlochbervie**
Watercolour sketching out of doors is a different game from painting, although sometimes the difference is barely perceptible.

◀ **Sketching in Africa**
Sometimes when you are the centre of attention, it is best just to concentrate on your work.

▶ COTTAGE NEAR KINLOCHBERVIE
200 x 305 mm (8 x 12 in)
This painting was carried out indoors, to compare with the watercolour sketch done on the spot. It is hard to beat the spontaneity of the original work.

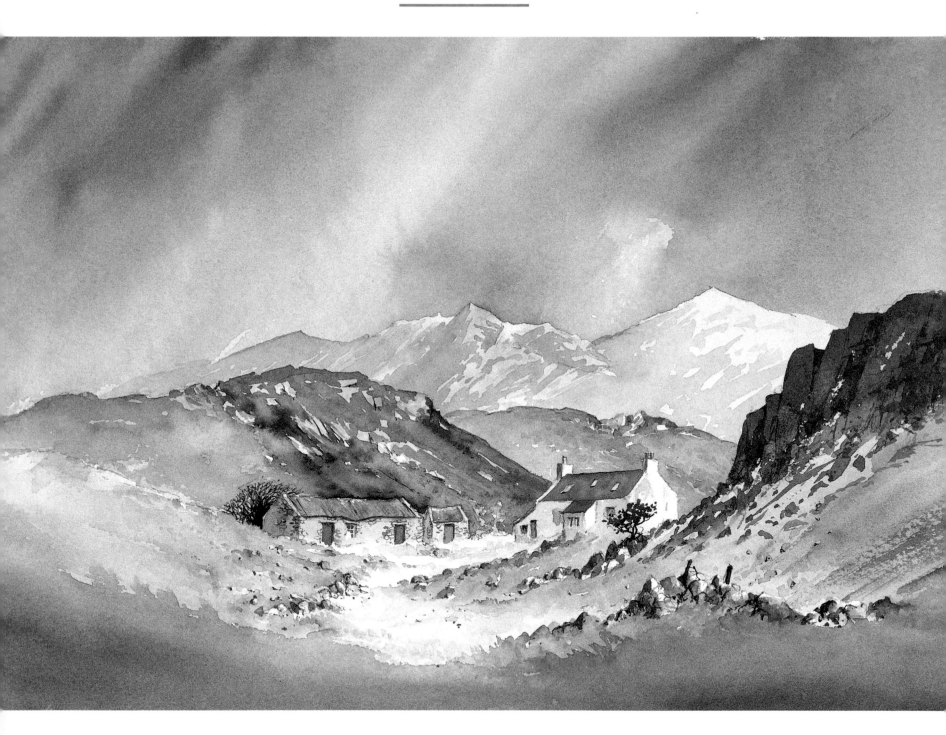

Extra Equipment

For painting out of doors, a few items of extra equipment are needed to enable you to work properly. An easel helps, but is not essential. Be wary of buying a lightweight one to save weight: more important is its ability to withstand strong gusts of wind and to provide a firm platform for working on. I find the metal Daler-Rowney Westminster easel first-class, as it is sturdy and offers little surface to the wind. In addition, its legs adjust to all sorts of awkward, uneven terrain – it is superb in uneven river beds. In strong winds I tie down the easel with 6 mm (¼ in) rope, attaching it to the ground with tent pegs, climbing hardware or simply a weight – a heavy stone in a bag, for example.

Most alfresco artists prefer to sit down when carrying out a painting, and after a

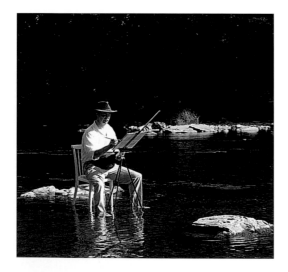

▲ **Be prepared for anything**
It is essential to be comfortable on location.

while a rock, tree stump or toadstool tends to become dreadfully uncomfortable. Lightweight stools, as found in angling or camping shops, are the answer; however, I have seen some eye-watering accidents with stools, so do test one before buying. Will it hold your weight? Might it unbalance you on uneven ground? Will it fit inside your bag, rucksack or whatever?

Outdoor Equipment

My father made himself a marvellous box-stool for fishing, which could carry a lot of equipment. However, I prefer to carry my gear in a rucksack, as it frees both hands and allows me to carry a heavier load in comfort. Rucksacks come in all sizes, but the critical point is that it should easily hold your largest board. These days there are a number of rucksacks available that also incorporate a folding seat, although I have not used one myself. The side pockets are useful for containing water bottles, pencils, and so on.

A spiral-bound pad of 300 gsm (140 lb) watercolour paper is a popular surface that many artists use when working outdoors, but make sure you take bulldog clips and elastic bands to prevent the paper blowing about. Even the slightest movement can turn a delicate brush stroke into an unsightly blob, and a sudden gust of wind can happen on the calmest of days. There is nothing like a piece of watercolour paper stretched on to a firm drawing board, because then you are less likely to encounter unintended marks caused by the wind. A good compromise is to use a

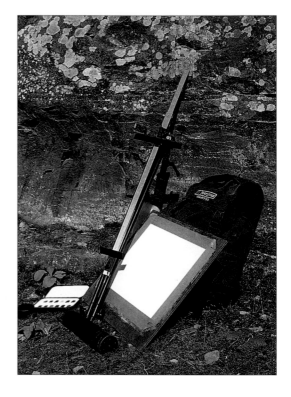

▲ **Outdoor painting equipment**

watercolour block which does not need stretching on a board. This sort of block is very useful when you are painting overseas, where carrying space may be limited.

Before going abroad to paint for the first time – or even on holiday in your own country – try out your alfresco equipment and manner of working locally. This will show up any weaknesses and potential problems, as it is quite a different matter from working comfortably at home. Often problems occur because something minor, yet extremely useful, has been forgotten. Don't forget to take lots of pencils, tissues, rags, a sharp knife and refreshments.

Changing Light

Over a period of two hours, the sun moves around a considerable distance in the sky. If you are working on a day when the sun makes its presence felt, you therefore need to take great care with light and shadows. Position yourself where the light can be viewed to best advantage, and aim to predict where cast shadows will fall when you reach the shadow-painting stage. Paint all the shadow areas quickly to ensure consistency. Attempting to alter them as the sun moves is a recipe for disaster. Take photographs at these opportunistic moments to back up the work.

◄ FIELD EDGE, COLWALL, HEREFORDSHIRE
180 x 230 mm (7 x 9 in)
The rough paper accentuated ragged edges on the clouds and dry-brush effects in the foreground. The distant trees were suggested with the side of the brush. Note that a hint of sunlight comes in from the left of the picture, causing a cast shadow to be thrown across the central area by the tree.

The Preliminary Sketch

Once you find your subject, walk around and make sure you find the optimum viewpoint. There is nothing so galling as spending hours on a painting only to find afterwards that there was an even more eye-catching view nearby. In most cases, begin with a brief pencil sketch to ascertain exactly where on the paper each feature will appear. This is one of the most important stages in the work. The sketch will also form a record of the scene, should you part with the final painting. While waiting for washes to dry, embellish the sketch with tones and colour notes, or make studies of features around you.

▲ Keeping the board at an angle ▶
Keep the work at an angle when laying a wash at the studio desk or the easel. With the board across your knee out of doors, use a towel to help get an angle of about 30 degrees, so that the wash has a fair chance of running smoothly, and to avoid nasty backruns.

Watching the Tide

A similar problem with painting a changing scene can occur in a tidal location. The tide is far more predictable than the light, but even so, it still catches many people out. Tide tables are invaluable, as they make it much easier to plan your marine painting, and if you intend to paint beneath cliffs, they give you an idea as to how long you can remain before being cut off by the tide.

Before working on the painting, consider what effect the incoming or outgoing tide will have on the scene – apart from there being more or less water. Will those lovely rockpools disappear, together with the reflections? Is that boat going to lurch over on to its side as the water recedes? How much of those mooring ropes will be visible? How much longer will that spray crash over those rocks? All these factors, and much more, will need to be considered as the tide

▲ Rusty old boat at Fishguard
Some rapid watercolour sketches glow with spontaneity and give me more satisfaction than a painting that has taken hours to complete.

changes, and if you can predict the effects you can work rapidly and exclusively on that part of the painting until it is complete. Alternatively, you can carry out sketches and take photographs whilst waiting for the washes to dry, for the purpose of recording the changing features.

A Premature Finish

Side-sketches and notes made in a sketchbook are not only an important extension to the painting, but can form valuable reference material if you are forced to stop painting before the work is complete. You should be able to predict

the likelihood of a premature stoppage because of a storm or whatever, and the possibility should always be borne in mind. The secret is to make sure you record the most important features of the scene with sketches and photography. Notes in the margin of the painting or in a notebook can also supply valuable information on as-yet-unpainted tonal relationships, colours, and other aspects of the scene.

Protecting Your Work

If the watercolour has progressed to a pleasing state, it is imperative that it is protected from rain, snowfall, sandstorms

◄ Cwm Bwchel Farm, Black Mountains
This scene was bursting with perspective problems, as I had to sketch over 60 m (200 ft) above the subject. In the sketch, all the horizontal lines leap away at sharp angles, pointing upwards as they recede, because my eye level was much higher than the subject. In such a case, a sketch is essential. When painting this scene, I would alter the perspective to avoid a feeling of vertigo.

and the like. It might be a case of quickly popping the painting into the car, but often it is not that easy. Shielding it from rain by turning it upside down will work, but if the washes are wet some pretty nasty backruns may well appear. A large umbrella can help, but if you are serious about outdoor painting it pays to construct some sort of protective cover. Heavy-duty plastic sheeting, preferably transparent, tacked to the reverse side of the drawing board, can be flipped over quickly to cover the painting, but you will need to keep it away from the surface. A strip of wood fastened to each side of the board will do this, provided the board is not too large. Some form of waterproof case might be the answer.

Once the work is safely protected, stop and consider whether you need any more reference material in order to complete it back at home. If so, quick pencil notes or sketching are invaluable. If the paper is wet, use a water-soluble pencil. With good planning before you leave home, you will be well-armed to cater for all sorts of problems that can devastate the unwary in the great outdoors.

A Good Way to Learn

Working up a painting out of doors is more frenetic than working indoors, and fraught with all sorts of potential disasters, but it gives your work more immediate appeal. If you are reluctant to try it on your own, join a painting course or class that paints alfresco. It is a marvellous way of improving your work.

▲ Brickbarns Farm, Malvern Hills
This simple watercolour had to be changed into a sketch because it was taking a long time to dry and the light was beginning to fade. I brought it to a finish quickly with a black watercolour pencil.

▶ BRIDGE ON THE RIVER USK
180 x 230 mm (7 x 9 in)
This outdoor painting is barely one step up from my watercolour sketches. The mass of various greens can cause considerable problems, but here I have reduced them and mixed each with a base colour of French Ultramarine to achieve a sense of unity.

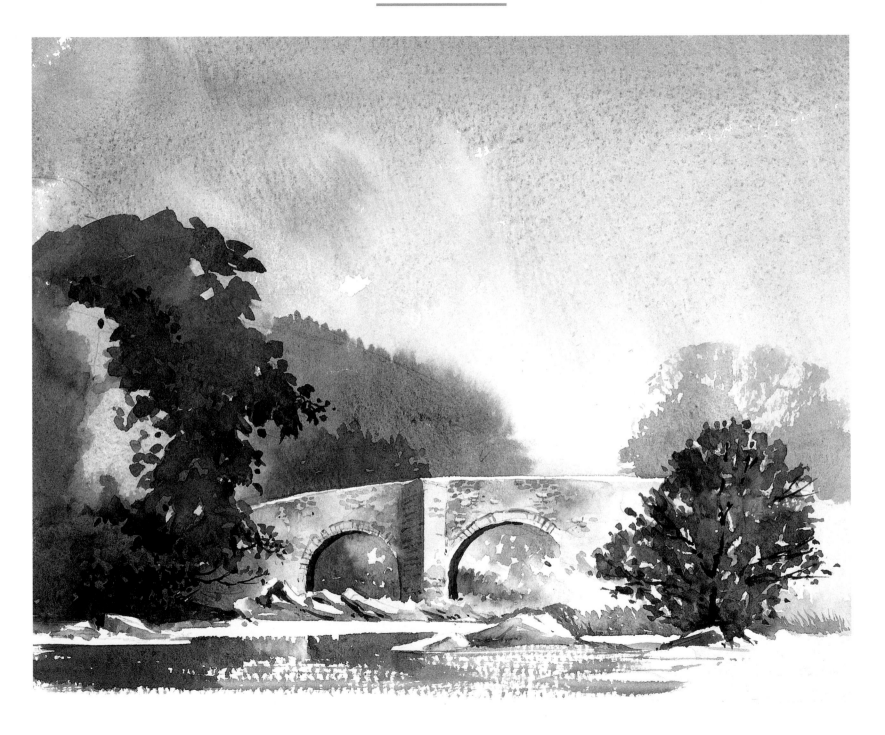

Giving your Paintings Impact

The emphasis in this section is on producing paintings that really work. It shows you how to turn your sketches and photographs into finished watercolours, and a variety of techniques demonstrate how to improve the basic scene and make it a pleasing composition. Stage-by-stage demonstrations take you along in logical steps, preparing you for the challenge of the exercises set at the end of each chapter. Lighting is of such immense importance that the whole of Chapter 6 is devoted to this fascinating aspect of painting, which can give your work considerable impact. You must always keep alert to that tiny or seemingly chaotic fragment of nature which, isolated in intense light, will spark off a glorious glow of inspiration inside.

▶ WATER MEADOWS
255 x 485 mm (10 x 19 in)
In this painting I wanted to create a sense of space, so rather than close in on the willow trees and the water, I painted a greater expanse to show more sky and rendered the trees smaller. This emphasizes the scene's horizontal nature and gives the sky more prominence, although this is only composed of washes of French Ultramarine and Naples Yellow. Most works benefit from quiet areas, which are quite dominant in this scene.

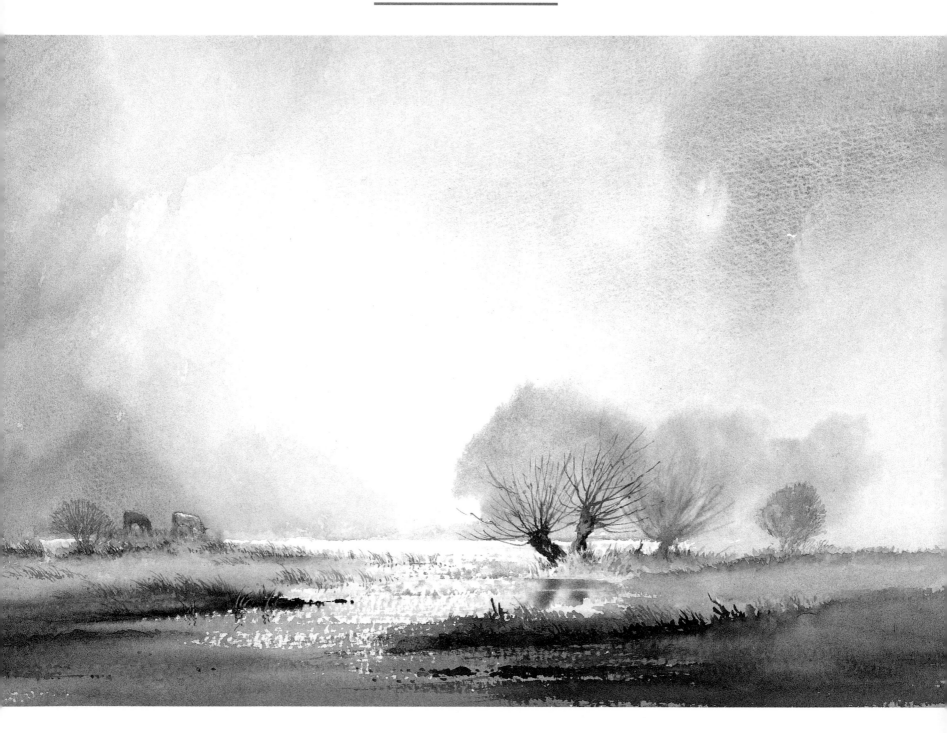

4 Using Sketches and Photographs

Not everyone wants to paint outdoors, and there will come a time when you need to work indoors from sketches and photographs. This chapter considers some of the ways to translate your sketches and source material into paintings, and hopefully to enhance the composition. While you may wish to make a faithful recording, there are few subjects that do not benefit from a certain amount of adjustment.

Having a great number of sketches and photographs available is essential, otherwise you are likely to fall into that old trap, 'The Rut', and not know what to paint next. Once you have decided on your subject, you need to spend some time planning the work, using the Planning the Painting Checklist on page 40. Try not to rush this stage, as I cannot stress how important it is to the end result. Planning a painting is covered in some depth in my book *Watercolour Landscape Course*, but here I shall explore further considerations.

Down to Basics

Here, it is worth looking at the actual application of paint to paper. Clean water, a clean palette and clean brushes all help to provide a clean wash, which is vital. For large areas a pool of colour should be mixed in a well or saucer beforehand. Test the colour and degree of tone on a piece of scrap paper, using as large a brush as you can. Apply the colour with as few strokes as possible, and refrain from using a brush as though you are cleaning the kitchen floor. Slightly overlap each stroke, trying not to go over parts already covered – too much will deaden the wash.

▶ WINTER SUNSET, COTSWOLDS
230 x 305 mm (9 x 12 in)
Sunsets allow little time to complete a work. With the emphasis on colour, the optimum method outdoors is a rapid watercolour sketch. In this final painting I have added the pheasant for foreground interest.

▲ **Hedgerows**
The amorphous nature of hedgerows, with wild tangles of plants, posts and bushes, causes considerable confusion. They normally work best if kept simple, with hard-edged tops broken down in places for variety. Apply detail here and there, but by introducing a change in colours – maybe even a bright red – you can maintain interest without the need for strong detail throughout the hedge.

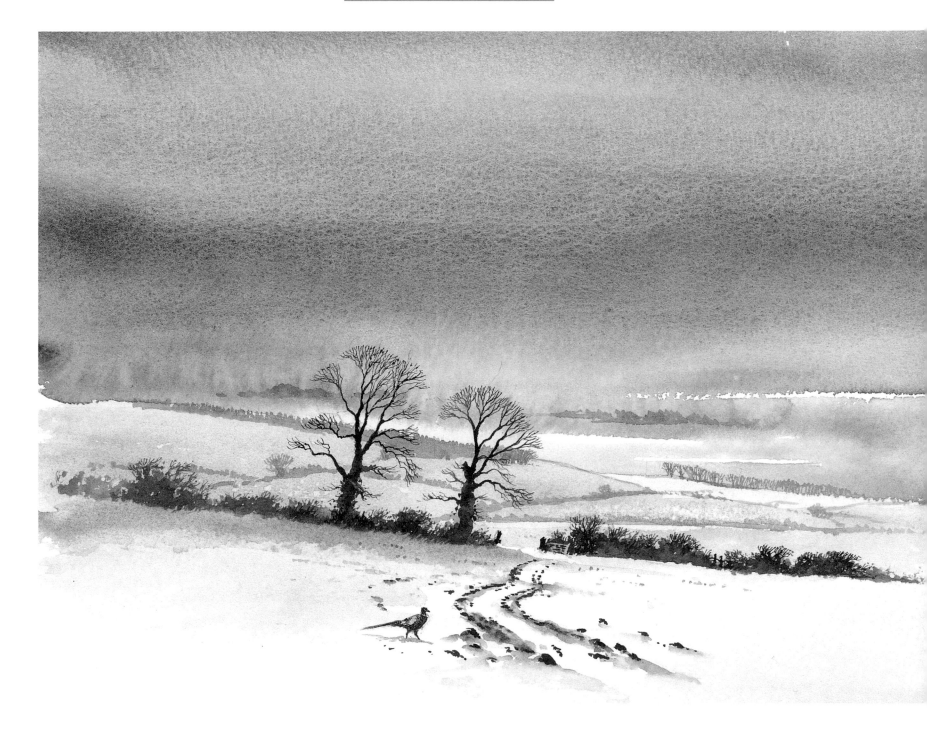

PLANNING THE PAINTING
Checklist

PAPER
✓ What type of surface will work best? For example, if texture is more important than strong detail, a Rough surface would be the optimum choice.

SIZE
✓ Does the subject cry out for a full sheet of imperial size, or a smaller one?

STUDIO SKETCHES
✓ Do you need to make a studio sketch? If the subject is fairly simple and you are working from a sketch, a studio sketch may be pointless, but if you are working from a photograph or increasing the scale considerably, a studio sketch is advisable.

Where you need a graduated wash – for instance, where a sky becomes lighter lower down – use more water in the mix as you work your way downwards. Work quickly, for in seconds it will start drying and you run the risk of ugly cabbage-like creatures emerging from the wash, especially if you are adding more water. Keep the board at an angle so that the washes run downwards and not into what has already been applied, which is a first-class way of meeting more cabbages. Watercolour tends to lighten in tone as it dries, so you need to apply it slightly darker than you wish the end result to appear. Experience will tell you by how much. Some pigments, such as Payne's Grey, will lighten considerably more than others. Never take the attitude that you can always go over it again, as this is a sure recipe for making mud.

The lightest tone in watercolour is actually the white paper, so for a white cottage, white clouds, sparkle on water and a myriad other highlights, it helps to keep that part of the paper virgin white. You will sometimes need to reserve white areas, for forming puddles, for example, or to add a bit of life around a focal point; if this is the case, leave larger areas of white paper showing than you actually need, as these have a habit of diminishing rapidly in the excitement of a wash.

The Studio Sketch

Use a layout pad, cartridge paper or scrap paper, and begin by roughing in your ideas for the layout of the composition. What

will you emphasize as the focal point? Is any feature to be moved, left out, altered in size or emphasis? Do you intend adding in features from another sketch or photograph? You need only work on a small scale at this point, transferring to a larger scale if the composition demands it.

Sky, Atmosphere and Lighting

All too often, the sky over a subject simply does not do it justice. At other times there are wonderful skies without any appropriate subject matter. It is worth making studies of skies, however fleeting, as they will pay dividends later. If all the emphasis in the composition stands on the right-hand side of the painting, then a judiciously placed cloud can balance the work. In the same way, cloud formations can be used to highlight a particular feature or focal point. Strong, dynamic clouds may be inappropriate for a tranquil river scene, for example, so take care when choosing your sky.

Atmosphere, like skies, can be changed to reflect the mood of the scene; sometimes it is as simple as changing the sky to a dark tone and the sea to a lighter one. Related to this is the light, and altering lighting conditions can cause complications. There are times when you come upon a view at the wrong time of day, or in indifferent lighting, so that a change is necessary to make the most of the subject. If this covers a major part of the composition, then any change in lighting should be planned with tonal representation in a preliminary studio

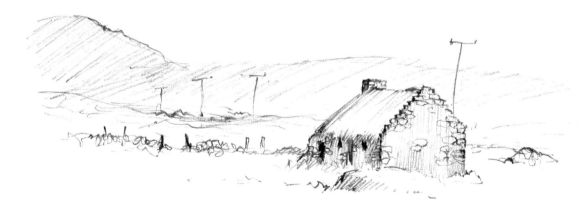

◄ Connemara Cottage
This pencil sketch faithfully records the scene as I encountered it in Ireland.

▼ CONNEMARA COTTAGE
230 x 330 mm (8 x 13 in)
The cottage looked desolate in the sketch and photographs, so I added a figure carrying a bucket, and suggested a faint path leading to the cottage. I also moved the distant hill closer towards the centre.

sketch. This will help to ensure consistency in lighting strength and direction. Cast shadows may be awkward to assess, and it takes experience to alter the lighting of a complex subject.

Introducing Additional Material

New material can be added to a painting for a variety of reasons: perhaps there is not sufficient detail on the sketch; maybe you have decided to work on a much larger scale than the original sketch; or unsightly features may need to be removed and the resulting gap filled with something else. At times it is simply a question of introducing, for example, a strong cloud or mooring post to one side to provide balance in the composition. Any such features added to a scene should always be in character with the subject. Studies and photographs of these details can prove invaluable in such circumstances.

David Bellamy

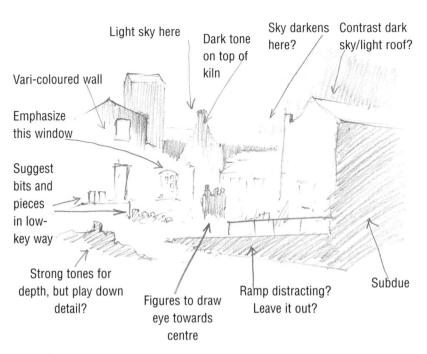

Light sky here

Dark tone on top of kiln

Sky darkens here?

Contrast dark sky/light roof?

Vari-coloured wall

Emphasize this window

Suggest bits and pieces in low-key way

Strong tones for depth, but play down detail?

Figures to draw eye towards centre

Ramp distracting? Leave it out?

Subdue

◄ Bottle kiln, Middleport Pottery
This type of studio sketch is useful in setting out your plans.

▼ The site as seen
In this version almost every detail has been included. The painting works, but how much better might it look simplified, by removing some of the clutter, as noted in the studio sketch?

Using a Studio Sketch

One of the most common and natural mistakes made by landscape artists is to overload paintings with too much unnecessary detail. A painting can have much greater impact if the composition is simplified as much as possible. This sequence of illustrations begins with an overworked version and considers how it could be simplified before removing some of the clutter and taking another critical look and making further changes. One studio sketch is used here, but in complicated compositions it is worth drawing up a number of different versions from the source material before making your revisions.

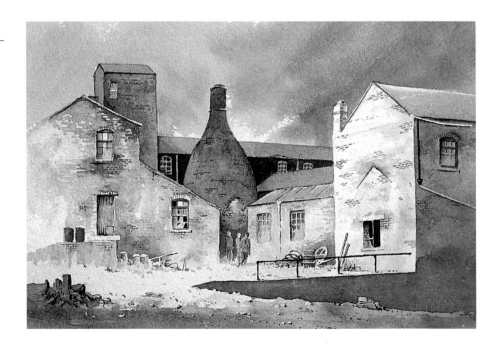

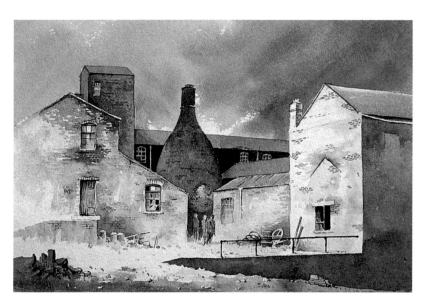

◄ Taking out the details
By getting rid of the two red barrels on the left and the second window to the right of the figures, the painting now appears less crowded. Additionally, the window on the far right was distracting, being so close to the edge of the composition, so removing it improves the scene.

▼ BOTTLE KILN, MIDDLEPORT POTTERY
200 x 240 mm (8 x 9½ in)
What happens if I really go to town and take away the foreground ramp and handrail, with its strong geometrical bias? By removing a few drainpipes for good measure, the end result is a much simplified and more pleasing version.

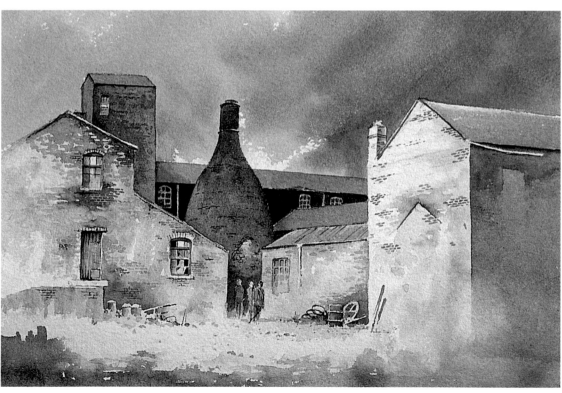

Demonstration

PRAIRIE BARN AND
CATTLE, SOUTH
DAKOTA
200 x 418 mm
(8 x 16½ in)

When I came across
this old prairie barn on
the edge of the
Badlands, it looked so
lonely and dilapidated.
As a composition it
needed balance to the
right, where nothing
but prairie stretched
away as far as the eye
could see. A few
hundred metres away
I came across some
longhorn cattle and felt
that they would add
both life and balance
to the picture. The dust
thrown up adds a
sense of atmosphere,
and the track has
been moved from the
left to a more central
position, to act as
a lead-in.

◄ Stage 1
In the upper sky Cobalt
Blue was laid with a
large squirrel-hair mop
brush, leaving white
patches to indicate
clouds; this was
warmed up lower
down with Naples
Yellow and Raw
Sienna. The light grey
areas were done with a
mix of Cobalt Blue plus
Cadmium Red.

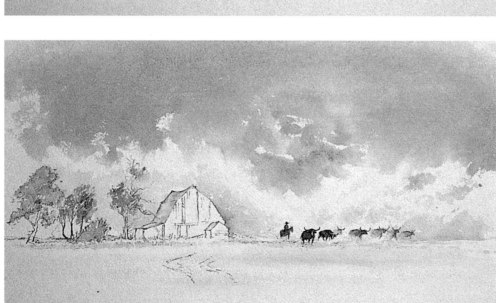

◄ Stage 2
Light Red and Cobalt
Blue were mainly used
for the cattle. The roof
was then painted with
Light Red and a little
Raw Sienna, and the
grass and foliage with
mixtures of Cadmium
Yellow Pale and
Cobalt Blue.

44

▶ **Stage 3**
More detail was added, introducing French Ultramarine with Burnt Sienna for the darkest parts, applied with a fine-pointed No. 4 sable brush.

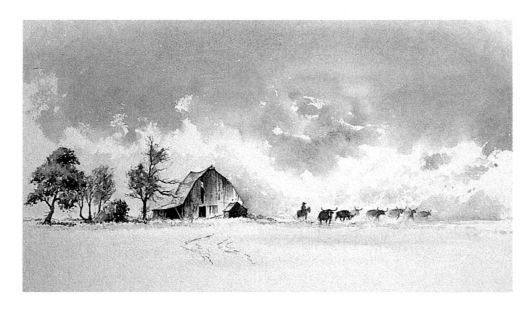

◀ **Stage 4**
Raw Sienna, French Ultramarine and Burnt Sienna were used in the foreground, with some light grasses picked out with Naples Yellow.

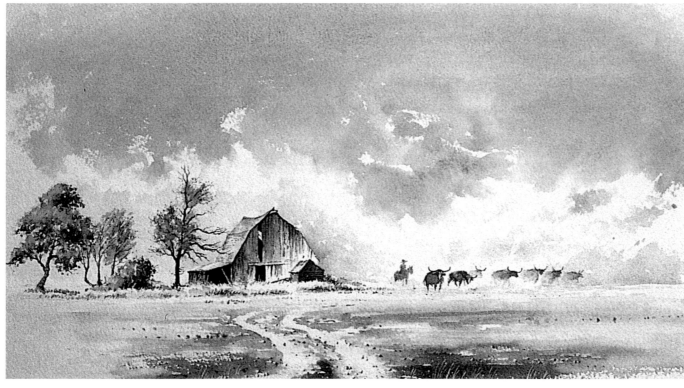

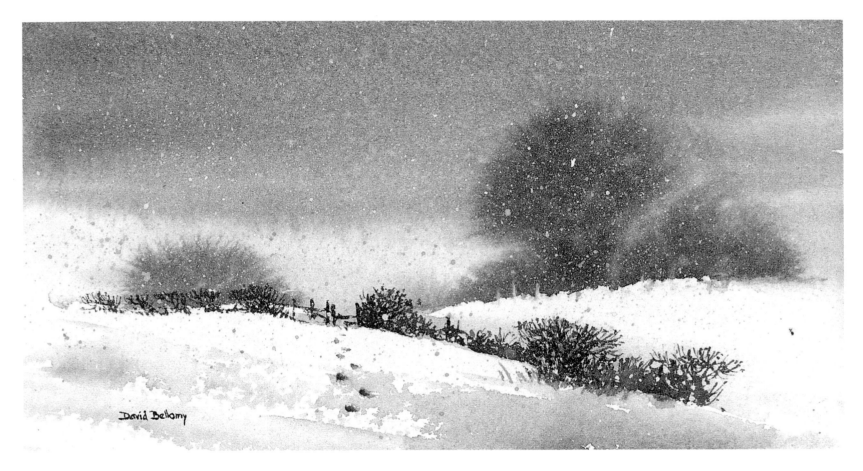

Imagined Places

For the landscape artist, introducing imagination into your work is easier once you have had some experience and are familiar with the type of landscape you wish to portray. If, say, you wanted to paint a typical Yorkshire Dales barn in an imaginary setting of trees and hills, adding perhaps a river and one or two characters, this is perfectly feasible if you are already familiar with that type of scenery. By calling it *Barn in Wharfedale* or that useful all-rounder *Morning Mist*, you will probably get away with it! A further possibility is, for example, to abstract the foreground and lose parts of the scene in a filmy wash. Considered properly, and allied to initial sketch studies, these imaginary works can at times look more authentic than the real thing. They are a useful ploy if you are housebound or unable to travel to a particular location.

▲ FOOTPRINTS IN THE SNOW
115 x 200 mm (4½ x 8 in)
Figures, weather effects, sky and atmosphere can all contribute strongly to an imaginary work. Here, the solitary footprints form a lead-in to the focal point of this painting.

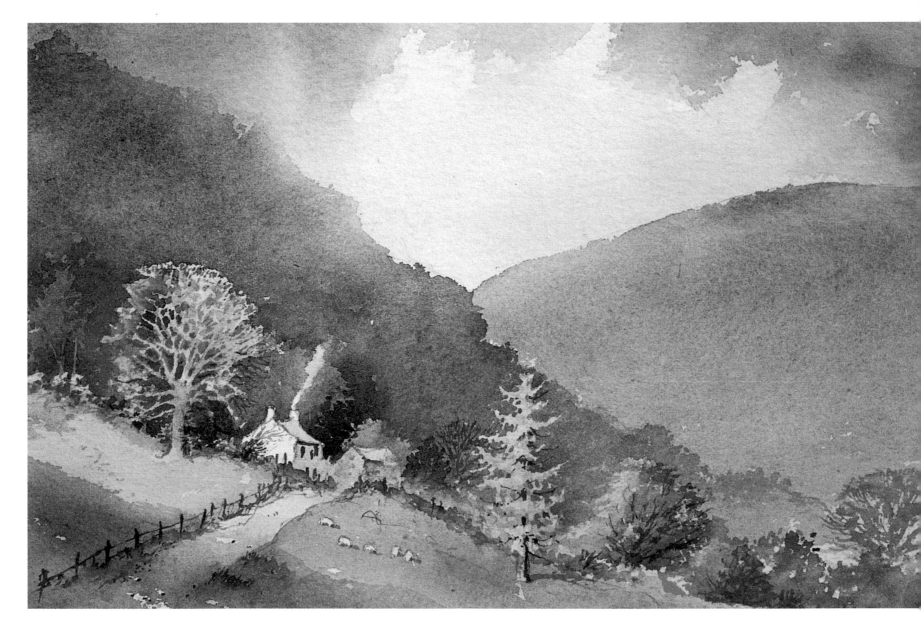

▲ COTTAGE IN THE BLACK MOUNTAINS
165 x 255 mm (6½ x 10 in)
If you can only see part of the subject, perhaps because it is hidden or far away, turn this to your advantage by using your imagination and painting experience to complete the picture. Here, the cottage was partly obscured in my original view of the scene.

Working on a Large Scale

Preparation is the key to large-scale work, and I am usually aware that the subject is likely to become a large painting when doing the original sketch. When this happens I make sure that I go home with sufficient detail on the sketch – often to the point of overloading it with information, as well as backing it up with photographs. To all this can be added studies of additional features that are in keeping with the subject.

Some artists like to draw a grid across the paper and sketch to provide a reference point for each feature as it is drawn in on the larger scale. However, I find this method cumbersome, destroying any fluidity, and of course the pencil grid has to be rubbed out, which is not going to enhance the paper surface. Avoid trying to cram too much detail into a full imperial painting, as there is a temptation to fill up each corner. Every painting, however large or small, needs quiet passages. You might find that a large wash drawing on cartridge

▲ MALGRUBENSPITZE, AUSTRIA (detail)

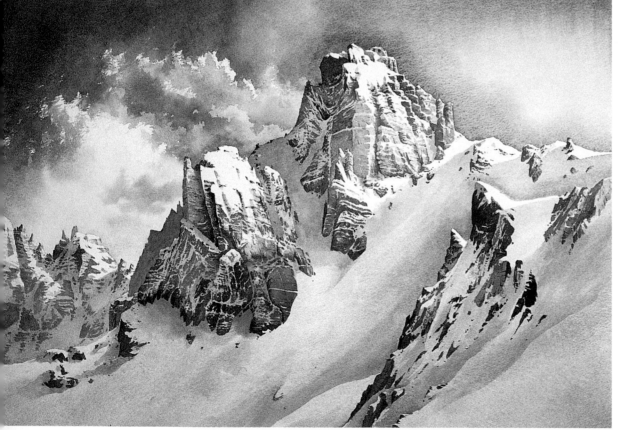

◄ MALGRUBENSPITZE, AUSTRIA
535 x 720 mm (21 x 28 in)
A full imperial watercolour takes considerable planning and execution. Late afternoon light caught the upper crags, turning them to gold. This contrast between light and shade was important to me, as well as the sheer grandeur of the scene. To emphasize the scale I have included two figures, which can be seen more clearly in the detail above.

paper will help you to assess the potential of the composition and establish where to place your main tones. This can simply be a basic sketch coloured in with washes, without any detail.

Using Photographs

If you work solely from photographs, carry out a sketch of the photograph first, make some colour notes and then put the photograph away before painting from the sketch. Working directly from photographs tends to freeze your work. The temptation to copy intricate detail is enormous, but this can make the painting too fussy; and if you try to include everything you see, you have very little chance of producing an effective painting. As in the original scene, you need to include only those features that are necessary to the work. On many occasions you will find it helps to work from two or more photographs from slightly different angles, as this will help you to see how features within a complicated passage relate to each other.

Exercises

Once you have absorbed the lessons of this chapter, try your hand at painting from the illustrations shown in the following two exercises. Take your time over each work and plan each one carefully. Also try experimenting with the techniques described in the chapter.

Exercises

▲ All the other exercises are done from photographs, but this sketch gives you an opportunity to use your imagination. Draw out the outline on a sheet of water-colour paper, and follow the sketch fairly closely when you work on your painting. When you have finished, compare it with mine on page 119.

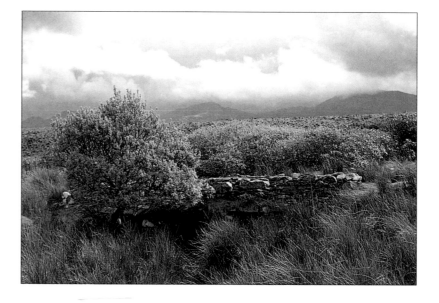

▲ This old bridge near Killary Harbour in the west of Ireland was rather overgrown, and the brook was hidden in the reeds. The sparkle of water, however small, adds life to the work, so include a hint of the brook in your painting. My version of this scene is on page 120.

5 Improving the Composition

The last chapter considered how you can develop paintings from sketches, and in addition hinted at some of those aspects of a scene that might be in need of some improvement. This chapter continues the theme by looking at various methods for further enhancing the composition.

The rules of composition are basically a guide, a structure on which to build up the painting. Just about every rule can be broken in certain instances, but until you gain experience it is advisable not to stray too far from the conventions, and even when you experiment, do so carefully.

The Focal Point

Every picture needs a centre of interest, or focal point. This is the part of the subject which immediately draws the eye and holds the gaze. When viewing a scene, the focal point is often readily apparent, as it tends to be the outstanding feature that drew your attention to the scene in the first place. Sometimes it is less obvious, due to competing objects. Because some centres of interest are completely dependent on the light, the focal point may even disappear before your eyes as the

◄ **Farm at Pinchbeck**
In this sketch I followed the River Glen until it led the eye directly into the farm which forms the focal point. A lead-in such as this can give your compositions much greater impact.

▶ LOCH LEVEN
200 x 305 mm (8 x 12 in)
Where you position the focal point is important: in the very centre of a picture looks totally out of place. Push it to one side of the centre and similarly above or below the halfway mark. Here, the cottage that forms the centre of interest is placed well to the left.

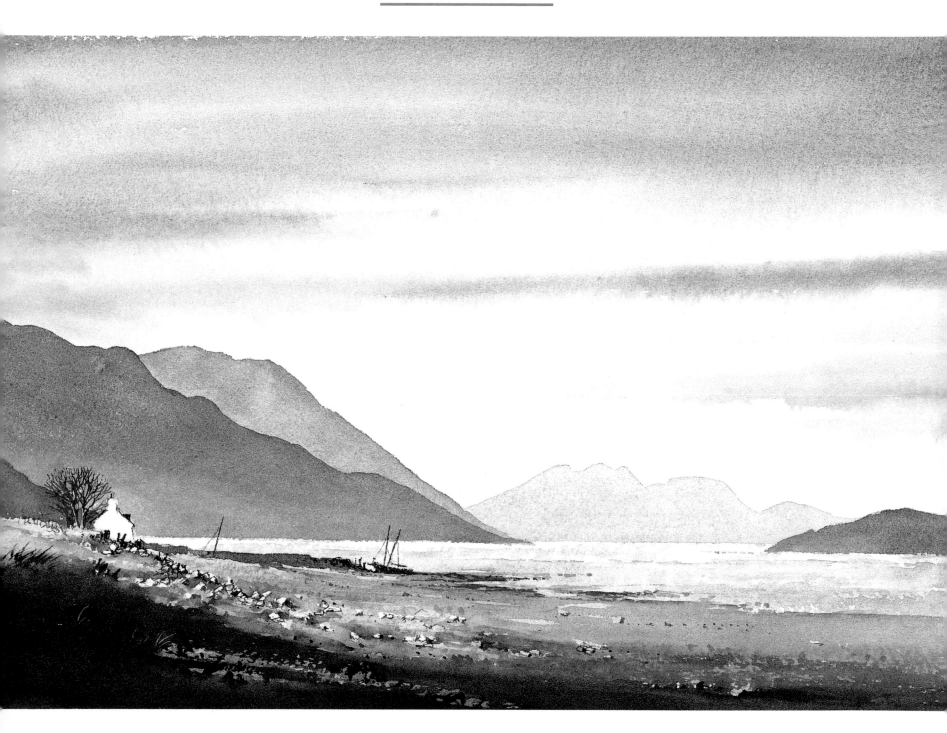

sunlight changes to cloud. Many times I have walked past a subject without giving it any thought, and then one day it is a riot of colour or reflections caught in sunshine, just calling out to be painted.

Creating a Focal Point

Many students fail to include a focal point, feeling that the general scene is appealing enough, and anyway there may be no outstanding feature. Even so, all that needs to be done is to create a focal point by applying more emphasis to part of the scene, using more contrasting tones, or introducing light, a figure or animal, or even something as simple as a gatepost. If you need to introduce anything of this nature it is wise to rough it out on a studio sketch before applying it to the painting.

Defining the Limits of the Painting

With a great many subjects it is fairly straightforward to work out where the limits of the painting will occur, but now and then you will come across awkward compositions. When you come to carry out the painting, hold two L-shaped pieces of mounting board over the original sketch, photograph or studio sketch, if you have done one. Move them about to form larger or smaller rectangles to help you decide on the limits.

Sometimes the limits can prove complicated, with one or more corners being too busy. The answer might be to vignette the work by losing the edge. This can be done at selected points around the

edge or completely round the picture, and is an extremely effective method, generally giving more emphasis to the focal point.

Moving Features

If you are painting a reasonably faithful portrait of a well-known scene, you do not have much latitude in moving things about. To improve the picturesque quality of the view, it is usually necessary to adjust the subjects here and there. A tree mass might only just appear above a building, looking a little odd; you can leave it out or extend it higher into the sky. Sometimes a mountain stream will benefit from the removal of a few boulders so that you can actually see the water.

Moving a gate closer to the focal point is a common practice, as it not only supports the focal point, but allows the eye of the viewer to gain access to it. In cases

where one side of the painting might be almost devoid of detail, a post, bush, dinghy or whatever may only need to be moved a little in order to improve the balance of the picture.

Using Props

Many features that can be moved are often already present in a scene, but there comes a time when you have to introduce objects that are not actually there, but which would be in keeping with that sort of scene. These are what I call props, and they can save a painting from looking thin or bare. Posts, puddles, bushes, rocks and similar features can be brought in to give interest or balance, so long as they do not look out of place. Although they are usually supporting features, there is no reason why they should not be employed as the focal point if necessary.

▼ Various types of props
Rocks, bushes, fence posts, puddles and mooring posts are the sort of features you can add to a composition to create balance or interest.

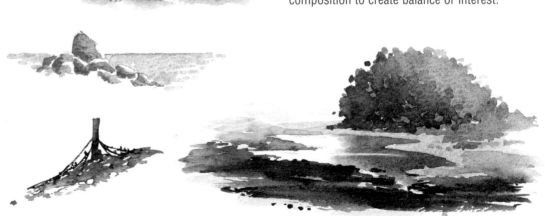

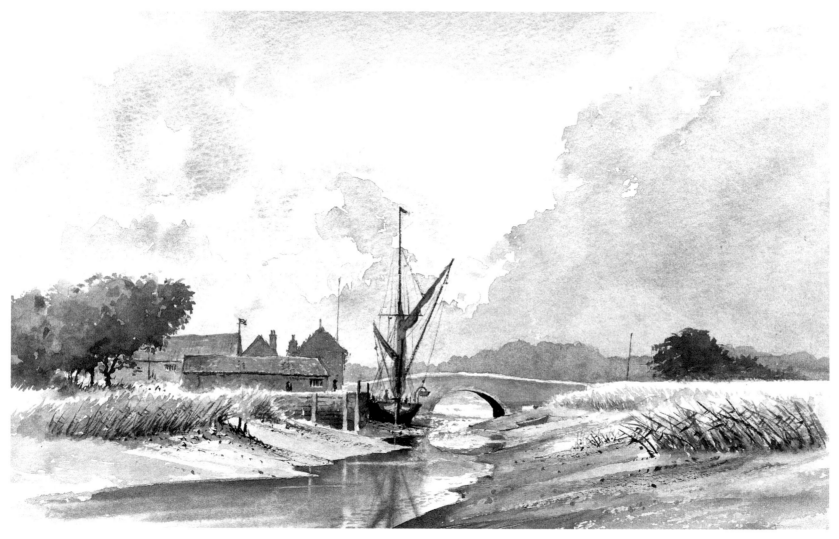

◄ **Sailing barge *Ethel Ada* at Snape Maltings**
In this sketch a boat masks the lovely stern of the barge, while another boat stands awkwardly on the other side of the creek.

▲ SAILING BARGE *ETHEL ADA* AT SNAPE MALTINGS
200 x 305 mm (8 x 12 in)
The sailing barge was my focal point for the painting, and as the stern lines on barges are so beautiful I did not want to omit them here. Because of this I had to leave out the boat hiding the stern, but of course I had then to observe the stern detail from close in.

Demonstration

BROGRAVE WIND
PUMP, NORFOLK
230 x 355 (9 x 14 in)

John Constable was
one of the first artists
to realize what an
important part the sky
played in a landscape
dominated by flatness.
Where there are such
large sky areas you
need to think about
how to manage them.
In this painting,the sky
is used to reinforce the
focal point.

▲ Stage 1
The low horizon takes
full advantage of the
vast sky. My aim here
was to paint cloud
formations that
complemented the
focal point. A mixture
of Cobalt Blue and
Permanent Rose was
prepared in a deep
well, and a wash of
weak Naples Yellow
was laid in the lower
part of the sky. The
prepared mixture was
then laid immediately
over the top part of the
sky and allowed to run
down into the Naples
Yellow, while retaining
an area of white paper
above and to the left of
the wind pump. The
ragged edges were
enhanced by the rough
paper. Note how vital it
is to have the mixture
ready in advance.

▲ Stage 2
The sky was allowed
to dry thoroughly
before weak Cadmium
Yellow Pale and
Permanent Rose were
applied into the hole in
the clouds, leaving
white edges in places.
A stronger wash made
up of Cobalt Blue and
Permanent Rose was
brought down over the
lower right-hand part
of the sky, allowing it
to run a little way
below the horizon. As
the ground would be
darker eventually, this
did not matter, and it
prevented an ugly
white or dark margin
appearing where
washes almost join or
slightly overlap. A
fairly strong mix of
Cobalt Blue and
Permanent Rose was
used to add some
hard-edged clouds
above and below the
cloud window. These
were softened off as
they retreated.

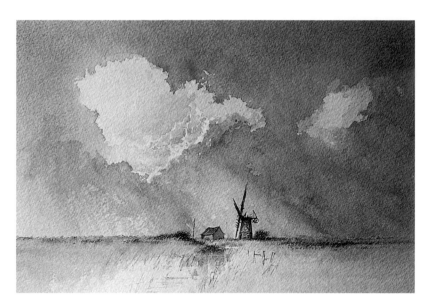

◄ Stage 3

Light Red was used on the hut, with a stronger tone on the roof, and the wind pump itself was rendered with Cobalt Blue and Light Red. The bushes and distant reeds were applied with a mixture of Cobalt Blue and Raw Sienna.

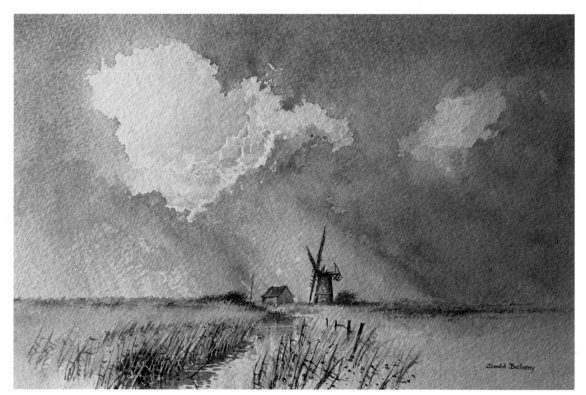

◄ Stage 4

The foreground reeds were painted with Cadmium Yellow Pale and Cobalt Blue, with some Raw Sienna. To reflect the sky, a weak application of Cobalt Blue and Permanent Rose was washed over the water. Finally the fence posts and stronger reeds were added with Cobalt Blue and Burnt Sienna.

1 Cool blue with no detail enhances feeling of distance

2 Darker blue-grey suggests a closer ridge

3 Warmer colour plus some detail brings the hedge closer

4 Red roof, strong tonal contrast and detail high-light the barn as the focal point, bringing it forward

▲ Rustic barn
This sketch illustrates the importance of colour temperature, tonal range and detail in achieving a sense of aerial perspective. The effect is intensified when all the parts are used together in one scene, as here, but each can contribute on its own.

Accentuating Depth

Recession, or aerial perspective, is suggested in a landscape by judicious use of tones, colour and detail, and, to a limited extent, the size of certain objects. Strong tones come forward into the fore-ground, while weak ones recede. Careful employment of tones will therefore suggest depth. Beware, for example, of the common error of making a hill too dark against a light sky. Compare the tone of the hill with those tones in the foreground, especially the darkest tone.

Sometimes, of course, a distant hill really is dark, and to paint it effectively that way you need to introduce warm colours – reds and yellows – into the foreground, with perhaps some strong detail to counter the darkness in the distance.

Making the distance appear in soft, light tones and cool blue-grey colours will accentuate depth and allow you to bring in stronger tones and warmer colours closer to the viewer. Even warm colours in the distance, caused by, for instance, warm evening light, can be counterbalanced by deeper tones and detail in the foreground.

Combining Boldness and Simplicity

Some students feel that it is a good idea to cram as much detail into a painting as possible. You do, however, need quiet passages where little is happening, to allow the work to 'breathe'. These passages can vary from plain washes of colour to broken washes, with some of the paper or an earlier wash showing through in places. They are necessary to provide impact to the more detailed areas, including the centre of interest. These quiet areas can be taken to extremes, where possibly 75 per cent of the paper has no detail. Try a few compositions in this style, as it will give you confidence to leave passages more simply delineated, even to the extent of leaving large areas of untouched paper.

Further Methods

There are many more ways of improving composition, but those described here give a basic guide to what to look for. 'Bending' cast shadows to fall in the best position, changing streams, fences and the like to provide a lead-in to the focal point, and modifying tones so that they do not appear like dark 'holes' in isolation, are further ways of enhancing your work.

Exercises

In the exercises your main thoughts should be to improve the composition in some way, for although the scenes make reasonably good paintings as they are, they would benefit from a few subtle changes.

Exercises

▶ **There is a lot of detail in this Pyrenean scene**, so consider first how you can reduce some of this, to give the important elements more prominence. Think of introducing a quiet passage where little is happening. Would the composition benefit from a lead-in of some sort? My effort is on page 120.

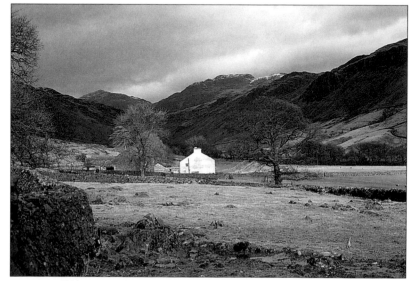

◀ **The white farm-house in Upper Eskdale stands out starkly between two trees**, with another tree seeming to grow out of its chimney. Is there too much detail on the distant mountains? What should be done with the wall and part of a tree in the left-hand foreground? My answer is on page 121.

6 Creative Ways with Lighting

Light is everything in a painting, and the quality of light is critical to the end result. The careful artist will time a sketching or painting trip so that the light is at its best when falling on the subject, according to the time of day. So often the light is not quite right, and you cannot lurk around in the half-light for hours on end, so what can you do to escape this predicament?

Light Direction

Perhaps the simplest aspect relating to light is its direction. It is vital to consider the direction of the light source before beginning a painting, and to keep this consistent throughout. A high angle will shorten the cast shadows and lead to a less interesting work. Foliage on trees, whether massed or a single tree, will show less definition, and most other objects will appear flatter. Painting around midday in summer will therefore not give you the most advantageous lighting conditions.

Early or late in the day, when the sun is lower in the sky, the angle improves shadows, casting them further, and the whole scene tends to be less harsh. With reduced glare and heat, it is also usually easier to work at these times. Consider whether the subject would be better lit in the morning or afternoon. Many crags on

▶ FARM ON MIDHOPE MOORS, YORKSHIRE
200 x 305 mm (8 x 12 in)
Here the sense of sunlight has been achieved by strong contrasts of tone on the building, and cast shadows. The painting was done on Bockingford Oatmeal tinted paper, and white gouache has been introduced to highlight the clouds. I used Naples Yellow, an opaque colour well suited to working with tinted papers, to suggest dressed stonework on the dark walls of the house.

▼ EVENING LIGHT, GALWAY BAY
115 x 330 mm (4½ x 13 in)
By leaving flecks of white paper in the central sky area and using the dry-brush technique for the water, the painting shimmers with light.

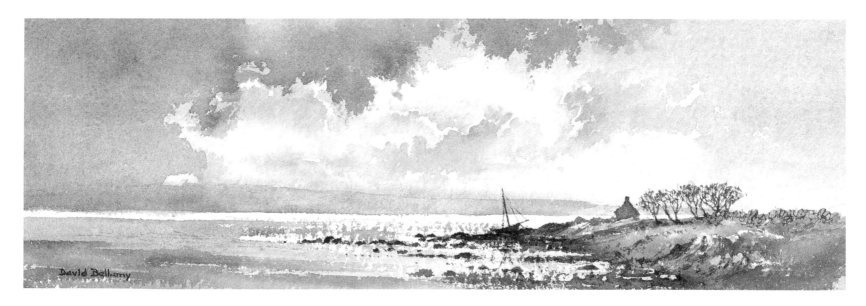
David Bellamy

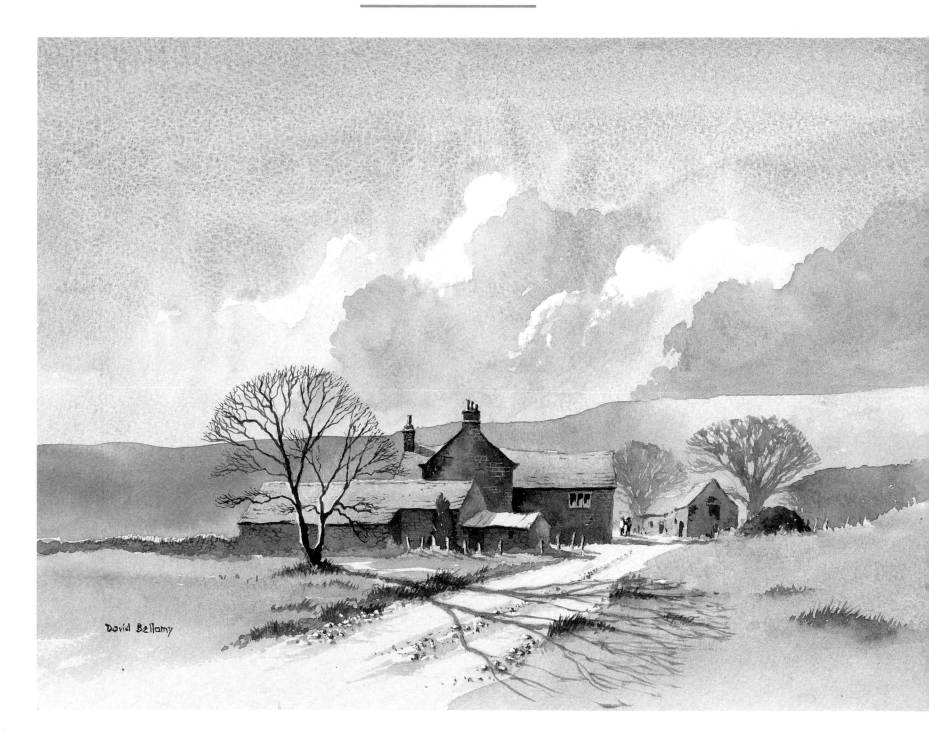

mountains only get the sun once during the day, and tree shadows falling across a bridge, for example, can make a sensational improvement if they fall in the right place. On a building, sunlight can illuminate two walls at 90 degrees to each other at certain times of the day, so choose the moment when one wall is more strongly lit than the other. This will make the building appear to be more solid.

The Power of Cast Shadows

By including cast shadows you will be employing the single most powerful manner of suggesting sunlight. Make sure the shadows all run the same way, and feel free to lengthen or shorten them to suit your needs, always bearing in mind the need for consistency. When outdoors, notice how shadows wriggle over ploughed furrows and dry-stone walls, for example. Animals standing in the shade of a leafy tree are usually visible only as silhouettes in the shadows. They make wonderful focal points when the field behind is kept dark. Snow-clad mountains can be difficult to paint on a dull day, when there only seem to be two tones – the white snow and the dark rocks. Bring in side-lighting, however, and shadows are cast into the gullies and behind crags, creating a middle tone and infusing the work with atmosphere. Shadows falling onto gates and stiles can transform an ordinary subject into one sparkling with varied lighting.

▲ Woodland gateway
In this sketch, the use of cast shadows and patches of sunlight suggests the dappled light of woodland on a sunny day.

▶ MOLVENO, ITALY
200 x 255 mm (8 x 10 in)
The effects of light and shadow on this fascinating corner of Molveno first caught my eye. The work was carried out as an alfresco demonstration for a group of holiday painters. The question of where to draw the limits of the composition was solved by focusing on the contrast of light and shadow and simply working in the immediate areas. Much of the texture on the wall caught in direct sunlight was omitted to provide a bleached-out effect.

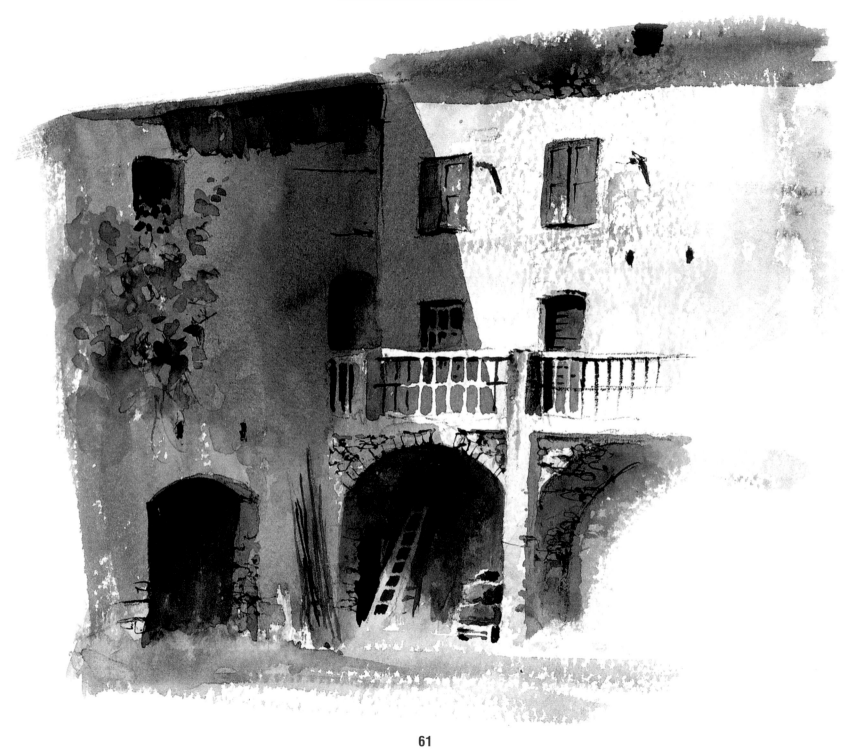

Demonstration

FARM, UPPER
SWALEDALE,
YORKSHIRE
230 x 318 mm
(9 x 12½ in)

Swaledale is a
wonderful place if you
enjoy painting barns
and farms. Here the
aim is to indicate
strong low lighting
cast across the
landscape, emphasized
by powerful contrasts
and cast shadows.

▲ Stage 1
Because the sky was
to be dark, I found it
advantageous to leave
the main part of the
sky until the lighter
moor had been
painted, following the
light-to-dark principle
of painting. A large
brush was used to
wash Naples Yellow
across the lower part
of the sky; Raw Sienna
was added as the sky
drifted down over the
moor, and some
Cadmium Yellow Pale

and Light Red were
dropped in here and
there. The building was
done with a mixture of
Cobalt Blue and Raw
Sienna, with a touch of
Permanent Rose.

▲ Stage 2
Once the first wash
had dried, a weak
application of Indigo
covered the sky,
shown here in detail.
This was reinforced in
places with a darker
mix to suggest clouds.
While the sky was still
damp, white cloud
linings were stopped
out with a shaped
piece of tissue paper.

▶ Stage 3
A mixture of Indigo and Raw Sienna was used for the distant left-hand hill. The stonework on the building was implied with Indigo and Light Red, taking this into the shadow areas as well. White patches were left at the top of the closest wall where it caught the light strongly. To the right of the farm a ragged edge suggests the rough moorland. This effect was achieved by dragging the brush horizontally along on its side on the Rough paper. The green on the lane was made up of Cobalt Blue, Cadmium Yellow Pale and a small amount of Raw Sienna.

◀ Stage 4
The tree was rendered with a mixture of Indigo and Burnt Sienna, as were the dark shadow and detail on the walls, and the figure and dog.

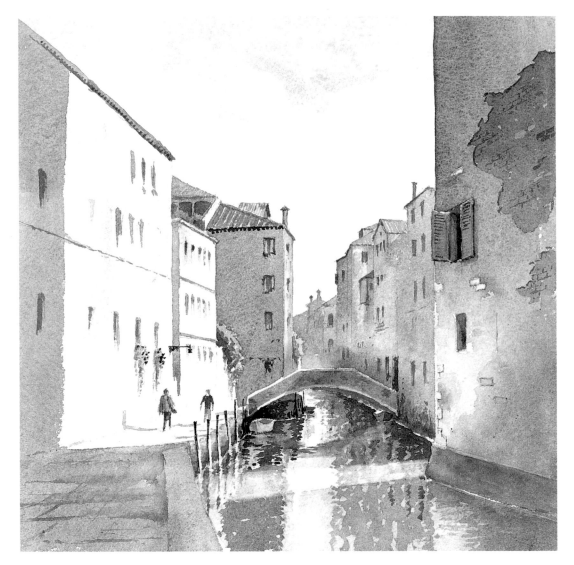

▲ VENICE BACKWATER
230 x 215 mm (9 x 8½ in)
Venice is full of light, which makes it such an exciting place to paint. For the large sunlit area I used a weak wash of Naples Yellow, the sense of sunlight being accentuated by the blue-grey wash applied on either side.

Sunlight and Shadow

Too much detail will detract from a sense of sunlight falling onto an area. An excellent lesson in this is to walk slowly along a stony lane with your back to the sun, preferably near the middle of the day. Fix your eyes on a point ahead of you in sunlight, holding your gaze there as you walk. Note how that point suddenly becomes alive with detail the moment your own shadow falls across it. This bleaching out of detail in strong sunshine can be taken to the extent of leaving the paper bare in places.

On windy days when clouds are being driven rapidly, the challenge of working outdoors provides some of the most attractive conditions for the landscape artist. However, attempting to capture the lighting as it constantly changes is as frustrating a task as controlling an easel in a tornado. Try not to keep altering your shadows as they move. Look hard at each area in turn, fix the optimum lighting arrangement clearly in your mind, and then apply the appropriate tone. Photographs help greatly in this instance.

Counterchange

Allied to this effect of light and shade is the technique of counterchange. This can change, for example, a dull ridge in the distance into a more interesting feature, without making it compete with the centre of interest. This is achieved by painting one side dark against a light sky, and the other side light against a darker

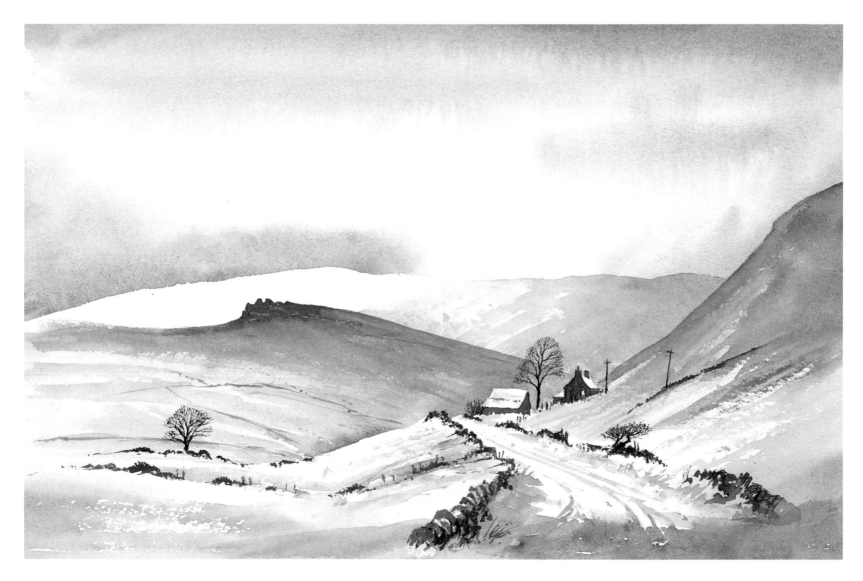

sky. Gradually changing the tone works best in these instances.

Other examples of counterchange are fences, hedgerows, bridges or walls partly in shadow, partly in sunlight, or by the degree of tone in their immediate foreground. When you are at the coast, watch seagulls caught in sunlight and see how they magically change from white against a dark cliff to a dark tone against a light sky as they soar upwards. Observe these kinds of effects carefully when out walking – you do not even need to be carrying a sketchbook!

▲ FLASH BOTTOM, NORTH STAFFORDSHIRE
230 x 380 mm (9 x 15 in)
Introducing counterchange on the furthest ridge adds interest without taking attention away from the farm. Raw Sienna was washed into parts of the snow areas to warm up the overall effect.

Demonstration

Direction of light

Dark to create depth

Focal point

Play down
(supporting role)

Less defined peaks

Keep this
area simple

Snow gully
lead-in

Include the
tree mass?

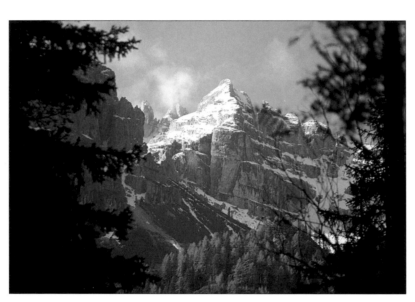

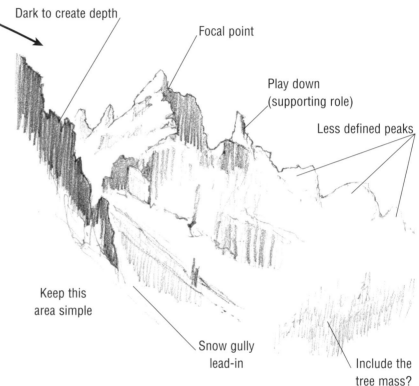

▲ **Monte Cristallo**
The photograph shows
the problem of having
part of the scene
hidden by trees in the
foreground.

MONTE CRISTALLO, ITALIAN DOLOMITES
280 x 485 mm (11 x 19 in)

Because part of the spectacular
mountain scenery was hidden, the
composition had to be created from
sketches made from a variety of
viewpoints. This demonstration
illustrates both the sequence of painting
and the preparation involved in planning
a complicated painting.

▲ **Monte Cristallo**
A studio sketch was
made to determine the
areas of emphasis.
The sketch shows
the need to be aware
from the start of
how you wish the
finished painting to
appear.

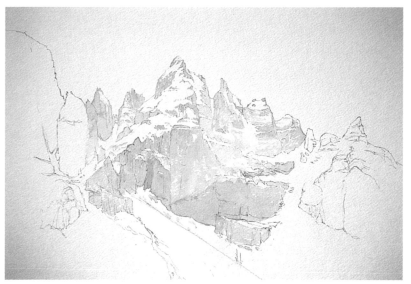

▲ Stage 1

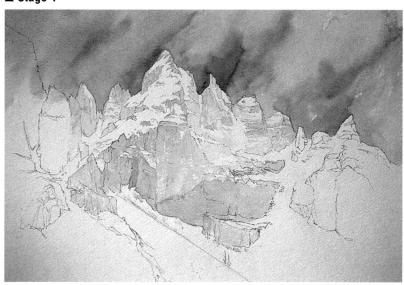

▲ Stage 2

Stage 1
A mixture of Permanent Rose and Cadmium Yellow was laid across the crags and allowed to dry.

Stage 2
The sky is usually painted first, but because in this painting it would be darker than the snow and crags it was applied after the crags were complete. The sky area was wetted with clean water, and then French Ultramarine and Light Red were dropped onto the wet paper to add strength of colour.

▲ Stage 3
Once the sky wash had dried, washes of French Ultramarine were applied for the light shadow areas. White paper was left for the highlights.

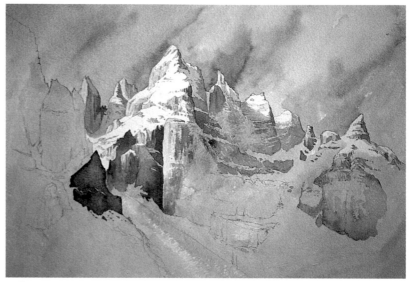

▲ Stage 4

▲ **Detail of the central crags**

Stage 4
Darker shadows were laid over the prominent crags using a strong mixture of French Ultramarine and Light Red, losing some edges here and there.

Stage 5
The left-hand crags were rendered next, providing a powerful frame to the focal point, and the lower slope was brushed in using the same mixture of French Ultramarine and Light Red as before.

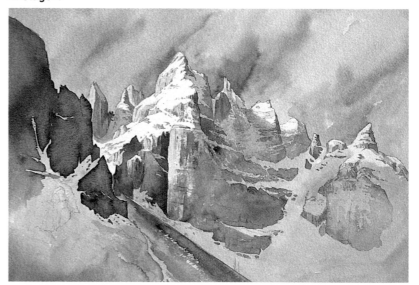

▲ Stage 5

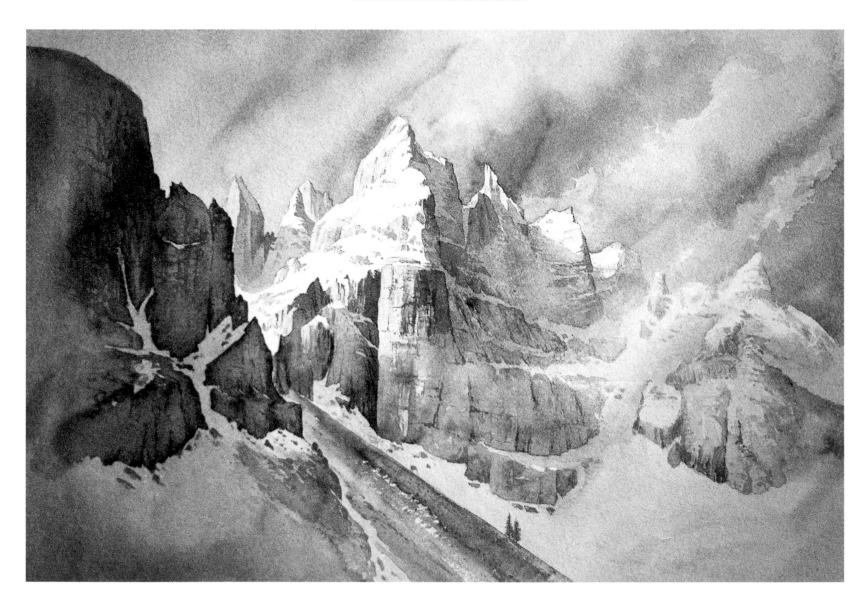

▲ Stage 6
The snow gullies on the left were darkened using French Ultramarine, and the right-hand peaks were played down by being washed gently with a wet sponge to create a more misty effect, which also suggested distance and gave more prominence to the central peaks. The diagonal clouds were then emphasized, more detail was drawn into the rocks, and the trees on the slope were added. These last provide a feeling of scale, as well as keeping the focal point of the painting central.

Highlighting a Feature

With indifferent lighting, there are many occasions when your work will benefit considerably from exaggerating contrasts or highlighting a feature with stronger lighting. While this applies particularly to the focal point, it can also be employed to effect on other parts of the painting. Make sure, though, that not every passage is given equal strength; consider making the background or surrounding area lighter than it actually is, before painting in the feature in strong contrast and perhaps adding cast shadows. If it is the centre of interest, it can be depicted as if it were lit by a spotlight, to accentuate its importance. Conversely, the background or immediately surrounding area can be made dark and the feature kept light, although this tends to be more tricky to accomplish. Strong shadows in the foreground are a common way of achieving this effect without having to use the 'spotlight' effect.

Reversing Tones

There are times when completely changing the tone in part of the painting will provide the key to success. Be cautious with this method; it is vital to try it on scrap paper before committing yourself. This technique works best where there is a preponderance of either dark or light tones, and a monotonous mass that needs to be broken up, an effect that frequently occurs in poor lighting conditions. Reversing the tones can add interest, for example, to a hedgerow, which if painted dark all the way across can look like a furry caterpillar tacked to the painting. With practice, this method can be effectively applied to most features.

Manipulating the Lighting

You are in charge, and there is no reason why you cannot change the whole painting in this manner, if you so wish.

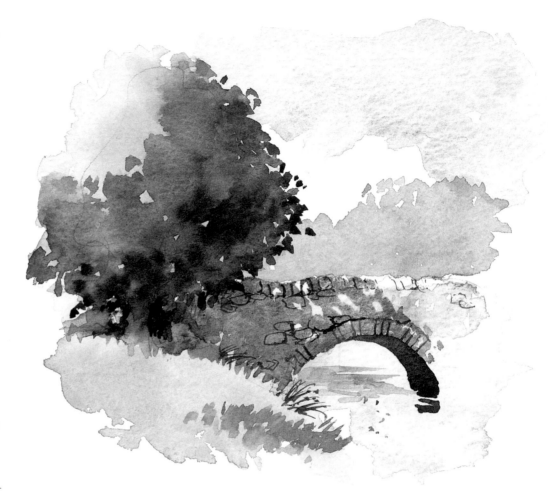

▲ **Cast shadows over bridge**
More of the bridge is in the tree's shadow than in sunlight, emphasizing the strength of the light.

Lighting is of the utmost importance in any landscape painting, whether you are trying to capture strong direct sunlight, an overcast day or the afterglow of a sunset. You cannot expect conditions to be perfect every time you sketch or photograph a subject, so a process of 'cooking the light' has to become part of your way of working – and you do not need to carry out a full painting to practise your cooking!

Exercises

These exercises are aimed at helping you to gain a better understanding of light effects, and of how to use them in your paintings, so make these your main considerations here.

Exercises

▶ **This barn in Connemara is a lovely subject, but the light is a little dull. When painting this subject, give thought to improving the light in part of the painting. My attempt can be found on page 122.**

◀ **Excellent lighting already exists in this scene on the River Clydach, but how do you tackle the background to emphasize the cascade? My painting is on page 123.**

More Exciting Techniques

O nce you have begun to master the basics, you will be eager to push your watercolours further and overcome those niggling little problems that at times can spoil an otherwise good painting. 'The painter must paint not only what he sees before him, but what he sees within him,' observed Caspar David Friedrich, a point well worth heeding. This section begins with mood, and how to capture that ephemeral quality of elemental power, or introduce it where you feel it to be necessary. Colour is something that many find difficult or exasperating, and Chapter 8 reveals some dynamic methods of employing colour to greater effect. Chapter 9 includes a whole range of further techniques to lift your watercolours out of the ordinary.

▶ FARM ON THE NORTH STAFFORDSHIRE MOORS
280 x 485 mm (11 x 19 in)
Some places, such as the North Staffordshire Moors, need good lighting for sketching, because on a dull day the stone buildings are often hard to distinguish from the ground. You often have to move around and seek out that optimum viewpoint. Here, the road offered the best angle.

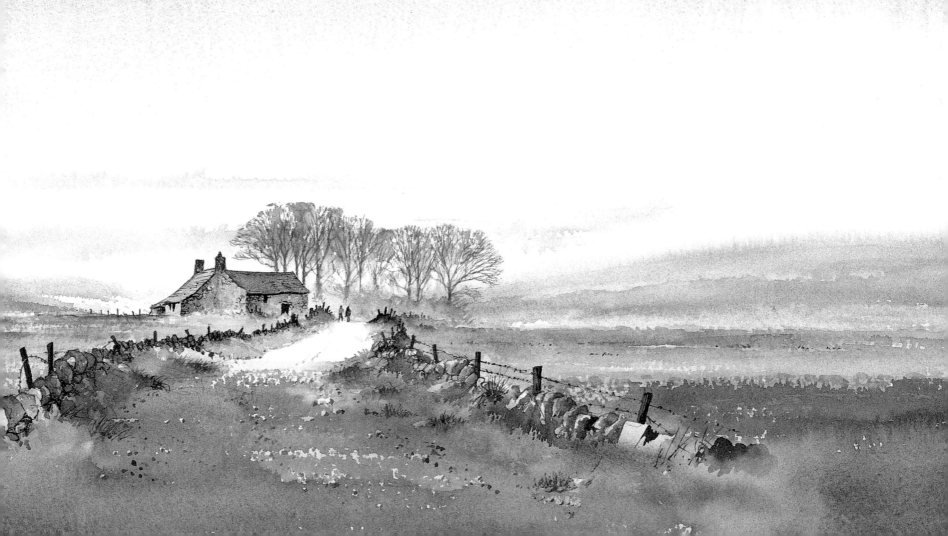

7 Injecting Mood

Few things in a painting can be more pleasing than achieving a powerful sense of mood or atmosphere, whether it be the tranquil cast of warm evening sunlight across a pastoral landscape, a rainstorm drawing a misty curtain over distant mountains, the intense heat of a Middle Eastern bazaar, or a crisp and frosty November morning. Nothing excites my palette more than sketching on a storm-racked mountain. Atmosphere adds an extra ingredient into your work that will lend authenticity and feeling.

The last chapter partly touched on atmosphere when discussing lighting effects, which obviously can impart a sense of atmosphere to a subject. It therefore pays to think about the sort of mood you wish to create when you are considering the lighting and sky treatment, as this can completely transform a scene. The sense of mood, and perhaps drama, which are often tied together, should be given attention at the same time as the lighting, since they go hand in hand.

Achieving a Sense of Unity

The prime consideration in achieving atmosphere is to create a sense of unity throughout the painting. This can be done mainly by using a limited palette, which reduces your colours considerably, and by having few jarring contrasts in tone, except perhaps for effect at the focal point. Scattered dark tones, for example, can make a work totally lack cohesion, as can flecks of white paper showing all over the painting. Although this last is very much part of the watercolour process, keep it to the area close to or at the centre of interest. Reduce isolated dark tones, and bring together any that remain with a

▶ CNICHT FROM CROESOR, SNOWDONIA
405 x 560 mm (16 x 22 in)
To suggest falling rain the paper was pre-wetted, the board tilted, and then the wash applied. Distant detail was faintly rendered, becoming more distinct towards the viewer.

▼ **Farm below Ochil Hills, Perthshire**
In this scene, atmosphere is more important than accurate topographical rendering.

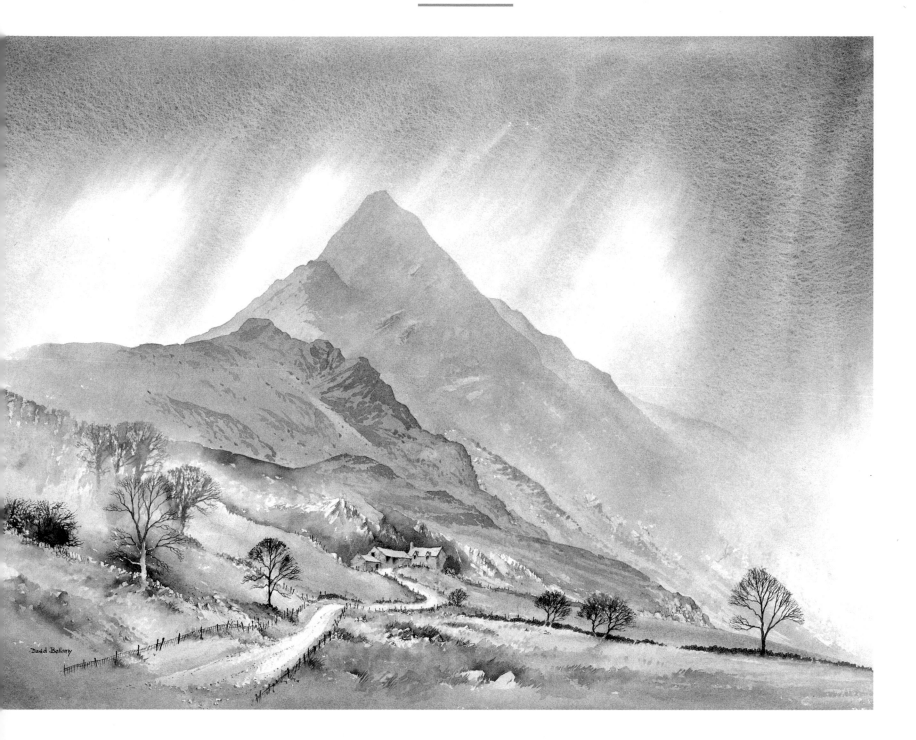

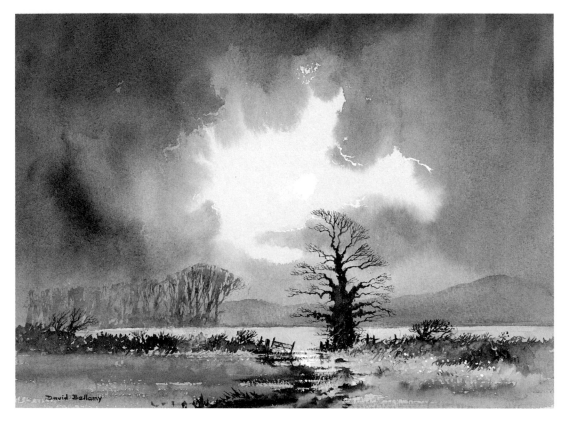

◄ HEREFORDSHIRE FIELDS
200 x 280 mm (8 x 11 in)
You can increase the unity and sense of mood by painting on tinted paper. This painting was done on Bockingford blue paper, using Monestial Blue as a base colour with which to mix the other colours. White gouache brought out the highlights.

medium-toned wash. A transparent glaze over the area can work well here, a technique illustrated on pages 94 and 95.

The Limited Palette

A limited palette can be beneficial. Firstly, it allows you to concentrate more on the tones than the colour, which can confuse where many colours are used; secondly, the fewer colours you use, the less likely you are to produce muddy passages, and you will thus achieve a cleaner watercolour; and thirdly, the limited palette enhances a sense of unity and mood.

Down the centuries artists have often begun a painting by laying an overall wash across the entire paper surface, using this as a base colour to accentuate this feeling of unity. These days Bockingford tinted papers replicate this technique, with the advantage that the colours cannot be muddied when laying the initial tint.

Taken to extremes, limiting your palette means working in monochrome, which is in itself a superb way of getting to grips with tones. However, in the context of creating mood, a limited palette consists generally of a few colours. One blue – perhaps French Ultramarine or Cobalt

Injecting Mood

Blue – will suffice as a base colour, with which many of the other colours are mixed. One colour should dominate the painting, possibly with splashes of other colours around or at the focal point. However, do not confuse the idea of creating a low-key painting with that of mixing your colours to the consistency of heavy-duty molasses; even the darkest of pigments should be applied with light, delicate brush strokes.

Designing for Mood

As well as by judicious use of colour, mood can be accentuated by the subtle application of pictorial design. To suggest tranquillity and calm, keep all the main lines horizontal, with one or two verticals to break up the monotony. Water should be smooth, with almost mirror-like reflections, and clouds should echo the predominance of the horizontal. On the other hand, a picture dominated by strident verticals will enhance feelings of awe, and even fear. By increasing angles closer to the vertical, crags and mountain-sides can appear more intimidating. Accentuating the height of a castle makes it seem more impregnable, especially if figures, dwellings and trees below it are made proportionally smaller.

Strong diagonals suggest a sense of dynamism and movement, and diagonally directed clouds with ragged edges will produce a sensation of strong winds and restlessness. Diagonals guided towards the focal point are an effective way of emphasizing its importance, and will produce lively compositions. Of course, the overall format of the painting should complement these aspects of design.

▼ CLEDDAU MOORING, PEMBROKESHIRE
150 x 330 mm (6 x 13 in)
The tranquil evening brought a marvellous sense of peace, which I have attempted to put over in the watercolour by emphasizing the horizontals.

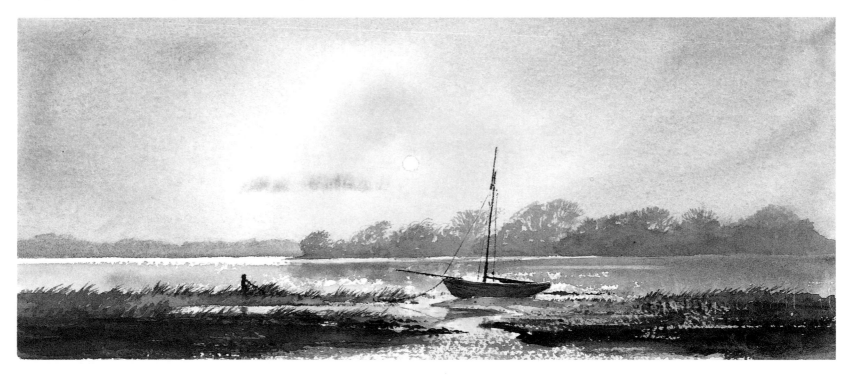

Demonstration

LLYN TRAWSFYNYDD,
SNOWDONIA
230 x 330 mm
(9 x 13 in)

In this demonstration
my aim was to inject a
strong sense of mood.
To do this I used
French Ultramarine as
a base colour, to unify
much of the fore-
ground and dark sky
area. I emphasized
this by a lack of detail
over most of the
painting, and no stark
colour contrasts.

▲ **Stage 1**
After the outline was
drawn, a wash was
applied to the central
sky area with a
mixture of Cobalt Blue
and Burnt Sienna.
Naples Yellow was
next dropped into the
lower sky, allowing a
further application of
Cobalt Blue and Burnt
Sienna on the lower
clouds to run into it.
The mountains were
painted in a flat wash
of Cobalt Blue and
Light Red, with a little

Cadmium Yellow
Pale introduced in the
middle. French
Ultramarine and
Burnt Sienna were
used for the darker
part of the sky.

▲ **Stage 2**
A mixture of French
Ultramarine and Burnt
Sienna was dry-
brushed across the
lake, and the dark
ridge was applied with
a mix of French
Ultramarine and Light
Red. Raw Sienna and
French Ultramarine
were mixed to wash
across the foreground.

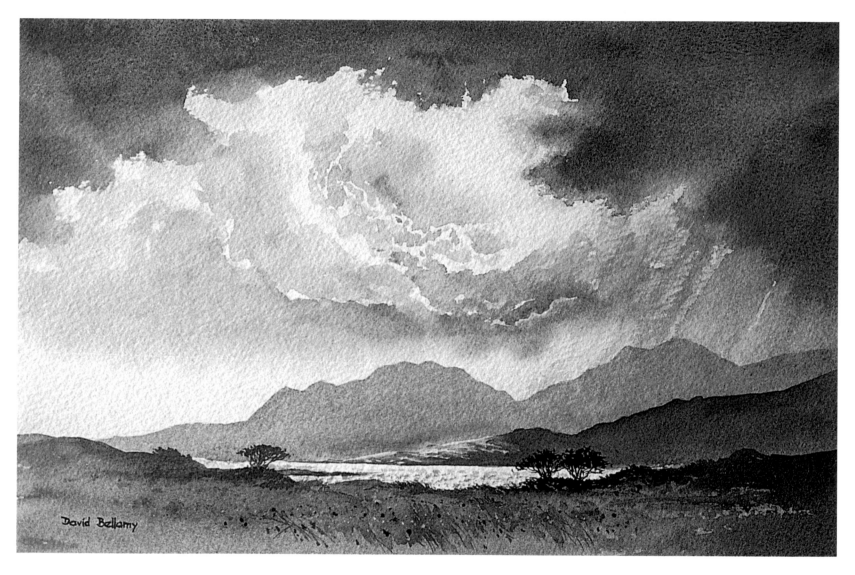

▲ Stage 3
The trees were inserted with a strong mixture of French Ultramarine and Burnt Sienna, and the shoreline was strengthened. Some detail was placed in the foreground to accentuate the sense of depth. Making the detail strong brought forward that part of the scene and further emphasized the sense of depth in the painting.

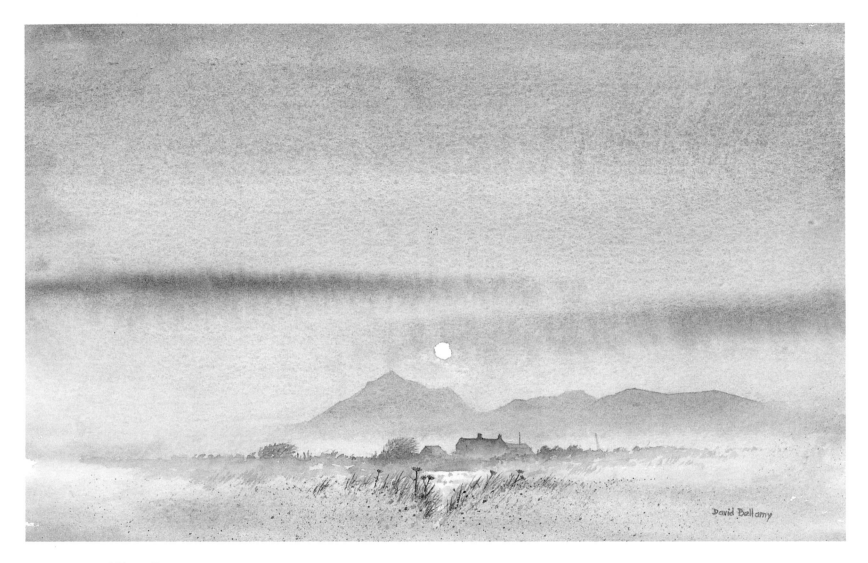

Misty Scenes

Mist is without parallel in creating atmosphere, whether used in part or over the whole painting. The wet-in-wet technique, where one wash is dropped into another that is still wet, is most effective in suggesting mist, and where soft edges are the order of the day. If you contrast these with hard edges in the foreground, the sense of mist is accentuated further.

Certain subjects react better to mist than others. On a day when a real pea-souper of a mist is prevalent, it is pointless to attempt to paint mountain tops. Instead, try painting rivers, streams,

▲ SUNSET OVER CARN LLIDI, PEMBROKESHIRE
200 x 355 mm (8 x 14 in)
Backlighting tends to unify the colours in the landscape, and this is accentuated when the sun is low and a hazy mist softens the features. Crimson Alizarin and French Ultramarine predominate in this work, and a vignetted foreground echoes the simplicity of the rest of the scene.

gorges, lanes with trees, and subjects that show a lot of detail. In thick mist, most of this detail is lost in the background, and everything is simplified considerably. With rivers or streams, pick a point where a tree, a fence descending into the water, a waterfall, or some definite feature like a rock can be used as the focal point; it should be depicted hard-edged against a soft background.

Where only part of the scene stands in mist, this contrast of hard and soft edges again works well. Light mist weaving in and out of crags can at times actually show more detail than strong sunshine; as the Reverend William Gilpin wrote in the eighteenth century, 'The ideas of grace and beauty are as much raised by leaving the image half-immersed in obscurity, as the ideas of terror.' A sponge can be effective in creating a soft mist hanging over a river or on mountain ridges or summits. Before attempting this technique, test the paper you intend to work on, to see if it will take sponging. Saunders Waterford and Bockingford are good, robust papers for this method, but not all papers will take such treatment.

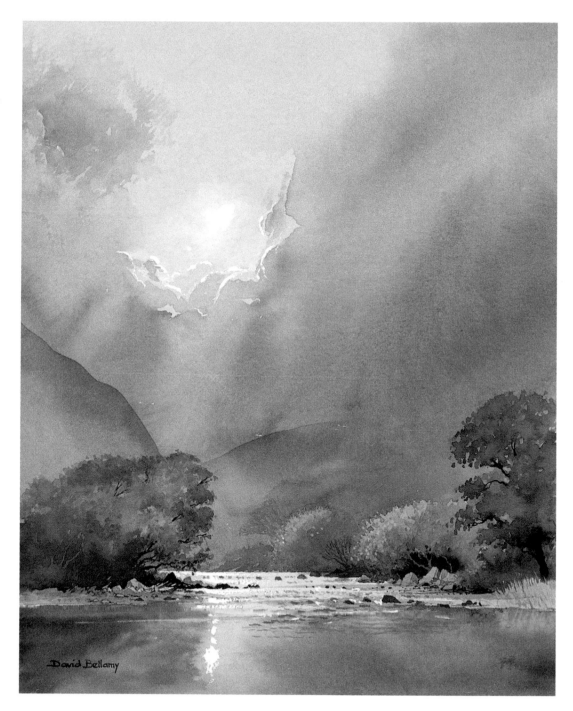

▶ RIVER SPEAN, CENTRAL HIGHLANDS
255 x 200 mm (10 x 8 in)
I used Bockingford Grey paper for this painting, to keep the background an overall shade of grey. The focal point was emphasized by creating a strong tonal contrast, using Indigo and Burnt Umber for the rocks juxtaposed against touches of white gouache for the sparkling water.

Demonstration

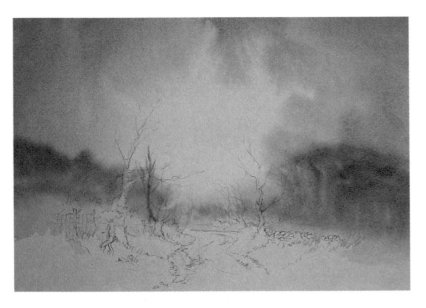

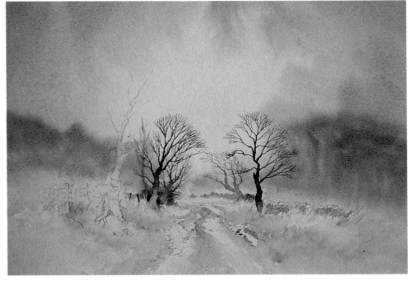

MISTY LANE
200 x 293 mm
(8 x 11½ in)

In this demonstration
I used one of the
most powerful ways
of capturing mood –
wet-in-wet. To achieve
success, you need
practice; poor results
indicate that you have
not yet wasted
enough paper. You
can use scrap or
cheap cartridge paper
for practising.

▲ **Stage 1**
A wash of weak Naples
Yellow was applied,
then a mixture of
Cobalt Blue and weak
Burnt Sienna was
immediately blended
in. After a few
moments a stronger
mixture of the same
colours was brushed
in, to suggest the
background trees. This
wet-in-wet method
works well with misty
scenes, but it is
important to ensure
that you have very little
water on the brush as
you apply the shapes
into a wash. Choosing
the right moment is
down to experience,
but try a piece to the
side first as a test
where it will not
matter. Some weak
Raw Sienna was then
washed in at the
bottom, keeping
everything soft-edged.

▲ **Stage 2**
The trees were painted
in with Cobalt Blue and
Burnt Sienna, making
the closer ones
stronger in tone. Raw
Sienna was applied to
the sides of the lane,
with touches of
Cadmium Yellow Pale
and Cobalt Blue in
places. The surface of
the lane was painted
with a mixture of Raw
Sienna and Cobalt
Blue, leaving parts
untouched.

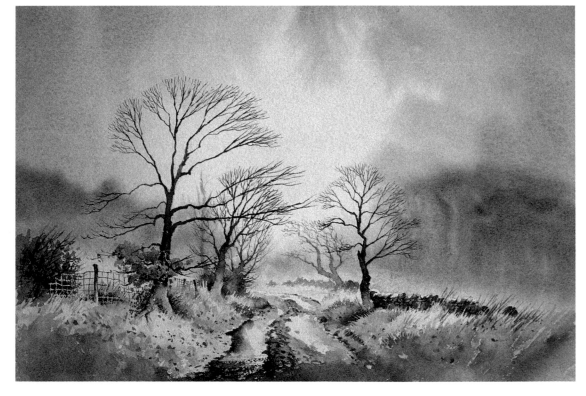

▼ Stage 4

The pig wire on the left was painted dark using a No. 1 rigger, and where it became light against a dark background a No. 4 round sable applied the darks, to suggest the light wire in a negative fashion. The detail on the right-hand wall was drawn with a rigger. Water was brushed over the puddle and a mixture of Cobalt Blue and Burnt Sienna dropped in to suggest the dark reflection, hard-edged on the left and blending into the wet area to the right.

▲ Stage 3

More detail was applied to the verges, and dead leaves on the left-hand tree were suggested with Light Red. Note how the fence posts are rendered – some light against dark and others vice versa, to add interest.

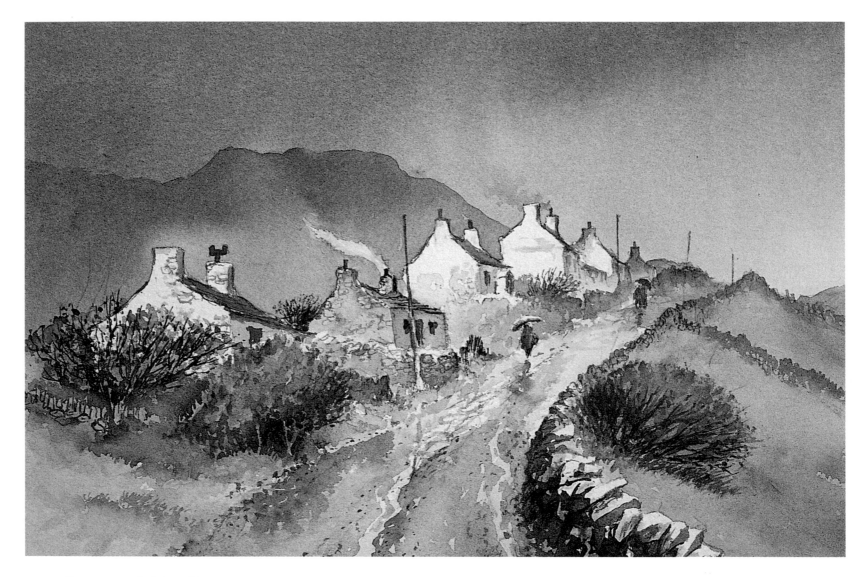

Storms and Other Horrors

With storms of all kinds the atmosphere is strong, lending itself to a limited palette approach. Greater exaggeration of the effects helps to convey the wilder elements. On the coast, breakers should be made higher, with deep troughs and plenty of movement. A dark, cloud-torn, angry sky emphasizes the nature of the storm, and in the main a low-key approach with an overall preponderance of darker tones gives more impact. Cloud studies are vital if you want to portray stormy skies

▲ WET DAY IN DINORWIC, NORTH WALES
230 x 305 mm (9 x 12 in)
The reflections and rivulets visible in the road and the umbrellas all convey the impression of a dismal day.

well, except perhaps in blizzards, where the driving curtain of snow engulfs everything. Trees and bushes leaning in the same direction suggest windy conditions. Sheltering animals and hunched-up figures further strengthen the impression of bad weather, and make superb focal points in a storm or a blizzard. Although many scenes lend themselves to stormy effects, be careful when using them, as they do not enhance every subject.

Subtlety and Method

Injecting mood into a work is not always the first consideration, but once you have mastered the basic elements of producing a watercolour, make efforts to include this extra ingredient. Much of the time it may not be apparent that introducing mood will improve the painting, but the more subtle effects often have greater influence – examine the work of Old Masters such as Turner, David Cox and Joseph Wright of Derby, all of whom were masters of atmosphere. Including mood will eventually become second nature, but it must be worked on and planned deliberately and methodically. It will have a remarkable effect on your work.

Exercises

The exercises here have been chosen to give you two contrasting moods to create – the tranquillity of a lakeside scene and the bustle of a busy thoroughfare – using the methods described in this chapter.

Exercises

▶ In this landscape of the Lake District, do you want the reflection of the mountains to stay as a mirror image? Should you bring out the weak detail on the mountains or lay a flat wash? Should you perhaps emphasize some of the trees as a focal point? My result is on page 123.

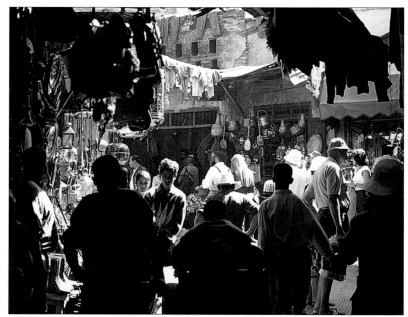

◀ It is quite a challenge to sketch in places like this Souk in Marrakesh, let alone to demonstrate watercolour painting! Would you include all these people? Can you detect a sense of mood or atmosphere beyond the foreground? Try to bring out some of the colour and lite, then compare your result with that on page 124.

8 Making Colour Work

The prospect of colour mixing, local colour, colour harmony and theories of complementary colours can be pretty daunting, even to those who have been painting for some time. Here I shall try to break through the mystique of this confusion and introduce methods of exploiting colour. How faithful should you be to the original colour found in the landscape? When should it be modified? Can you introduce colours that are not present? Are we ignoring the most potent colours in a landscape – as Renoir wrote in 1918, 'The colour isn't on the leaves, but in the spaces between them.' The next few pages will help you to be better equipped to deal with these challenges.

Secondary

Primary

Primary

Secondary

Secondary

Primary

◄ **Colour wheel**
This simple colour wheel is made up solely of primary and secondary colours. The arrows indicate the pairs of complementary colours (which always lie opposite each other on a colour wheel), and explain more clearly some of the references in other captions in this chapter to the technique of juxtaposing complementaries.

Complementary Colours

Complementary colours are those opposite each other on the colour wheel, as illustrated above right; by positioning them adjacent to each other, you can create tremendous visual impact. This has to be done with care and feeling, as it is another way of using colour to highlight a certain area within the painting. All of this may sound fine in theory, but how can you apply it in practice? Again, examples best illustrate this point.

The effect of autumn gold and orange leaves caught in sunlight and set against a backdrop of distant blue or blue-grey hills, is one of the finest examples of adjacent complementary colours at work in nature. This glowing effect can be visually breathtaking when effectively translated onto watercolour paper.

To take another instance, a riotous splash of violently red flowers, such as geraniums, in a hanging basket containing a mass of greenery has an explosive quality. This is perhaps best epitomized in a sun-drenched Mediterranean village scene, where large areas of whitewashed buildings and walls act as a background and further emphasize the effect.

▶ BEECH WOOD IN AUTUMN
180 x 255 mm (7 x 10 in)
Autumn is a notoriously difficult time for watercolourists, as light colours against a darker background are not easy to paint in detail. Here I took advantage of complementary colours, with the yellowy-orange set against strong blue. This accentuates the colour vibrancy. The yellow was painted first, reds were dropped in, and when these dried the blue was painted in.

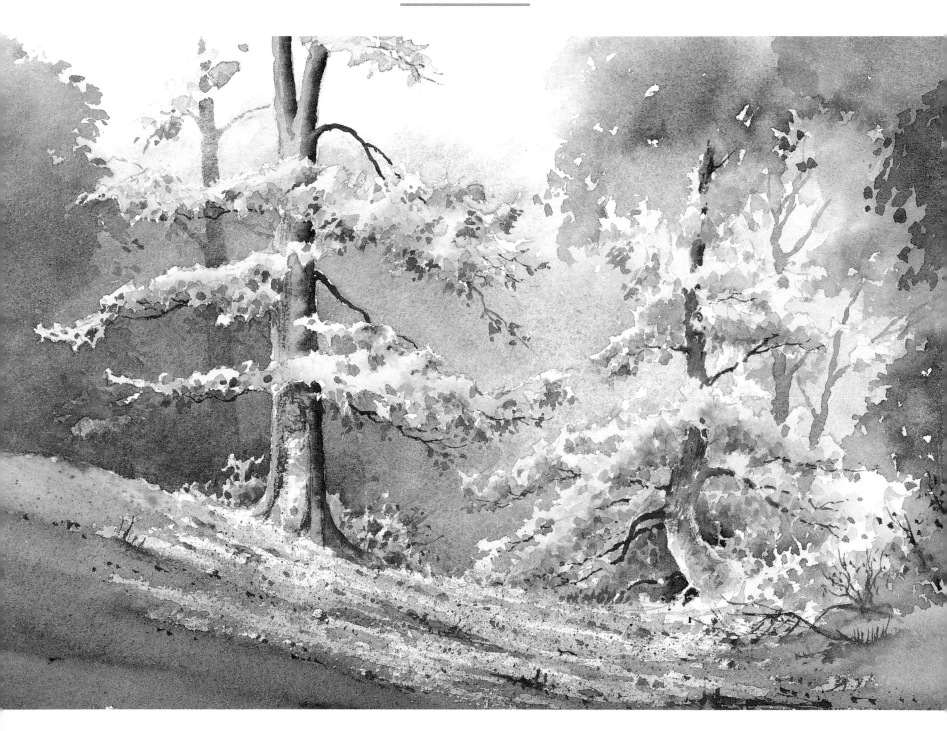

Colour Mixing

There is no magic formula for mixing colours: a mixture of Payne's Grey and Cadmium Yellow Pale will produce a lovely rich green, but how much grey, how much yellow, and how much water? Only experimenting with mixing colours will tell you and allow you to gain the experience necessary to create successful combinations of colours.

A methodical approach will help your colour mixing enormously. Take one colour and use it as a base colour, mixing all your other colours with it in turn, to see what can be achieved. Try different strengths of each colour and record your results on charts. You will waste an awful lot of paper trying out various colour combinations before you become adept at colour mixing, but it does pay off. In general, it is best to mix only two colours, but sometimes adding a small amount of a third colour can obtain your precise requirement. Beware, however, that too many colours in a mix will simply produce unsightly mud.

Mixing on Paper

Mixing colours on paper creates a much different result from palette mixing. If dropped into a wet wash, the colours will generally retain at least a suggestion of their own basic colour, but they will weaken. Colours applied on top of a dark tone that is still wet will lose much of their effect, but this method can still work, for example, where reflections in water are

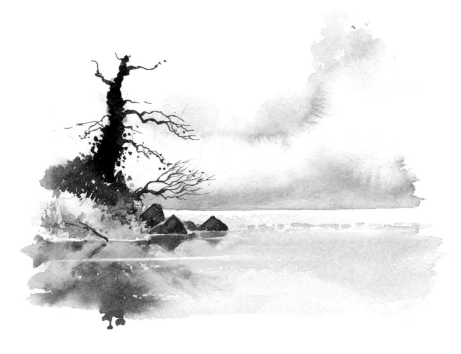

▲ Mixing colours on paper: reflections
After applying all the colours on the bank, I laid a wash across the lake of Cobalt Blue with a touch of Burnt Umber. While this was still wet I dropped in the colours seen on the bank, allowing them to run into each other and only slightly shaping them with a brush – too much poking about results in a sludgy, muddy colour. Generally the colours lose sufficient intensity to appear as reflections, but if you are unhappy with the result, wait for the paint to dry completely and then superimpose a weak glaze of light blue-grey.

▲ Mixing colours on paper: walls
When painting an old wall, I often drop colours in while the base wash is still wet. Sometimes these colours are exaggerated for effect, especially if the wall is part of the focal point. Once the area dries, I then work detail into it with a fine brush to suggest stonework.

◄ Mountain scene
The colour harmony in this watercolour sketch is achieved by using a series of blues, with stronger tones in places, especially towards the foreground. To retain harmony in the picture, the addition of any non-blue colours should be done carefully, allowing the blue to dominate in any mixture with new colours. If you are unsure about doing this, it is worth constructing a chart of mixed colours before carrying out the painting; clearly indicate which colours were used in each mixture, for future reference.

needed. It is essential to apply the colour in a stronger strength than you wish the end result to appear, but only experience – and quite probably a few mistakes – will tell you by how much. As with other methods described in this book, it is worth spending time practising mixing on paper.

Other instances where this technique is useful include vari-coloured walls, hillsides showing a number of colours softly running into one another, vegetation and rocks. Mixing on paper is like trying to shoot a charging lion – you usually only get one chance, and if it goes wrong, there's a mess all over the place. Done successfully, however, colour mixing on paper is an exciting technique that lends vibrancy to your colours.

Colour Harmony

Colour harmony implies that all the colours are in sympathy with one another and there is no note of discord present. This presents a pleasing picture to the eye, and helps us achieve a sense of mood. Harmony can be achieved by, for instance, mixing all your greens or greys with the same blue, and by not using colours which will jar with others in the work. Test combinations out on scrap paper before using them. While colour harmony can be employed throughout the painting, some of the most striking effects are achieved when it is limited to just the background, and the focal point then stands out in contrasting colour and strength.

Demonstration

**KEBLE BRIDGE,
EASTLEACH,
COTSWOLDS**
230 x 293 mm
(9 x 11½ in)

In a snow scene it
pays to include some
warm colour where
you can, otherwise the
scene can be
overwhelmingly cold.

▲ Stage 1
Once the drawing of
the scene was
completed, masking
fluid was applied to the
fine snow details,
using an old brush.
Masking fluid can
damage brush hairs,
so wash the brush
thoroughly in warm,
soapy water
immediately after use.
A pale wash of Naples
Yellow was used to
flood the sky area, and
a mixture of French
Ultramarine and Burnt
Sienna was then
immediately allowed to
run down into the
Naples Yellow. With so
much water flowing,
some desperate
mopping-up was
needed at the nether
end of the sky before
some French
Ultramarine was
applied over the field
beyond the bridge.

▲ Stage 2
Raw Sienna was
applied to the trees
and bushes, dropping
in Light Red here and
there. A mix of French
Ultramarine and
Cadmium Red was
used for the distant
line of trees and
shadow areas on the
left-hand trees. The
mass of bushes on the
right was applied with
a strong mixture of
French Ultramarine
and Light Red.

90

▶ **Stage 3**

The two middle-distance trees were rendered with French Ultramarine and Burnt Sienna. More work was carried out on the bridge stonework, bushes and reeds, using mainly French Ultramarine and Burnt Sienna applied with a rigger. The snow shadows were painted solely with French Ultramarine.

Stage 4

More detail on the trees and fence posts was drawn in with a rigger, using French Ultramarine and Burnt Sienna. The water was started with a wash of Naples Yellow, and the reflected colours were dropped in while this was still wet. Reflections are not as intense as the objects being reflected, so although the same strength of colour was used, when dropped into a wet area the colour lost much of its strength as it dissipated. While the river area was still wet, a 13 mm (½ in) flat brush was drawn across it horizontally, using the brush sideways to create a thin sliver to break up the reflections. To complete the painting, strong details were added to the riverbank.

▲ Stage 4

◄ TRAWLER AT SEA
230 x 330 mm (9 x 13 in)
Without the yellow in the sky, this painting would lose much of its visual appeal. Always consider the use of colour at the planning stage of your paintings, rather than halfway through.

► BOISTEROUS SEAS, PEMBROKESHIRE
240 x 318 mm (9½ x 12½ in)
Most of this watercolour was done with Indigo and Burnt Umber, creating an almost monochrome effect. The spot of Cadmium Yellow Pale on the wave near the centre therefore has more impact, standing alone in a grey sea. Spot colour like this can be highly effective.

Modifying Colour

In any subject, whether landscape, still life, life study or portraiture, colour is affected in many subtle ways. It can be modified by light, reflected light, shadows, distance, adjacent colours, reflections, water, and a great many other things, some of which are obvious, some not. Whitewashed walls of buildings are particularly prone to subtle changes caused by reflected light, reflected colour and shadows. The local – or actual – colour is therefore changed when viewed under certain conditions.

Apart from these subtle changes in colour, you may wish to alter the colours in your painting, perhaps to break up monotonous greens, enhance the focal point with bright colours, bring greater attention to a certain area with more powerful colour, or increase unity by reducing the number of colours or by laying a glaze across a passage. Changing the colours in a scene to suit these needs is therefore a valid and potent procedure.

Chaotic Colours

The colours in a scene often present a chaotic mess, totally destroying any semblance of unity. An idyllic cottage that has been decorated with purple walls might not quite harmonize with its surroundings, or perhaps a farmer has left a bright yellow combine harvester next to a lovely old barn. Most colour intrusions are unlikely to be so large or blatant, but they can be equally irritating in their own way. Subdue such unwelcome intrusions.

Nature itself sometimes needs a hand to turn a view into a painting, so there is a constant need to make colour adjustments to creatively improve work. It is rarely necessary to slavishly copy the precise colours that you see; indeed, where the variety of greens in, for example, a summer meadow becomes overwhelming, reduce the number to, say, a manageable three or four, and concentrate on the relationships between these colours.

David Bellamy

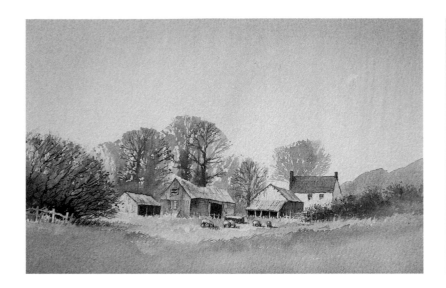

Colour Intensity

Colours lose their intensity when viewed from further away. The intervening atmosphere introduces a bluish tinge, gradually blending all the colours together in the far distance into an overall blue-grey or blue-purple, according to the light. A common fault, seen in many landscape paintings, is that of making the greens in the distance as warm and powerful as those in the foreground. The problem can be rectified by continually comparing the strength of the greens close by with those in the far distance. This is best done by isolating the greens with a viewfinder.

Once you start seeing green on a donkey's backside, you are well on the way to becoming an artist, as you are observing colour for itself and not assuming that, because it is a donkey, it must be grey or brown. Of course, you may never have the fortune to come across a green donkey...

Glazing

There are times when, although a completed painting may appear to be a competent rendering of the subject, it gives the impression of lacking unity, or it needs warming up or cooling down, or the focal point lacks impact because there is too much clutter surrounding it. One extremely powerful method of creating a feeling of colour harmony is the technique of glazing. This, however, can go sadly awry for the unwary, and should be carried out with great care.

Properly executed, a glaze can totally transform a painting. It is simply a transparent wash laid over that part of the painting you wish to harmonize, using copious amounts of water. In order to have the best chances of success use the largest brush possible, as the fewer strokes made, the better; a soft-haired brush, such as a hake, is best.

▲ FARM IN GOLDEN VALLEY, HEREFORDSHIRE (above left)
280 x 343 mm (11 x 13½ in)
Knowing I was going to lay a glaze on this painting, I made life easier by working on a Rough surface, but the same technique can work just as well on a Not paper. The completed painting looks cold in temperature, and the white farmhouse competes strongly with the barn as a focal point.

Glaze over sky and background (above)
Because the central barn is what excited me most about the scene, I wanted to emphasize it as the centre of interest. I mixed a fluid wash of French Ultramarine and Permanent Rose in a large well and, with the painting absolutely dry, applied a diagonal wash with a 50 mm (2 in) hake brush, working the strokes away from the buildings – this gave me greater control next to the buildings at the start of the stroke. Here, the end result has warmed up the painting, made the sky more interesting, and heightened the importance of the barn in the scene.

Only use transparent pigments, which will allow the colours already laid to show through. The colours being worked over should be absolutely dry.

Laying a glaze on Hot Pressed paper is likely to end in disaster, but Not is better, and Rough is more likely to give you a greater chance of success, because the brush touches less of the paper. Try not to go over an area more than once, and use as few strokes as possible. This technique is potentially damaging to the painting, especially if you use HP paper, work while the painting is still damp, or brush across it as though you are sandpapering.

If you wish to try this technique, use an old watercolour that has not worked and experiment with glazing over part of the painting. It can also be done over small pictures painted on scrap Not or Rough paper. Gain experience in this way before attempting the method on a full painting.

Practice Makes Perfect

For the successful watercolourist, knowing how your colours work is crucial. Learn as much about how colours interact as you can, by experimenting with colour mixes and the techniques discussed in this chapter – gradually your work will benefit from using them.

Exercises

Use the techniques and methods described in this chapter on the exercises, which will test your knowledge of colour and your ability to represent it effectively.

Exercises

▶ Try this autumnal woodland scene, reducing the amount of background tree detail and perhaps considering a lead-in to the focal point. Place emphasis on the use of spot colour for effect. The sheep can be omitted if necessary. My version is on page 124.

◀ For this exercise, pick out those elements that suit your purpose. Do you include part of the house at the rear, the telegraph pole, the foreground fence or the wall? How can you introduce more colour to advantage? See page 125 for my attempt.

9 Creative Experiments

How can you inject that extra sparkle into your work and make your paintings glow with vitality? The methods already discussed in this book will help you achieve this aim, and this chapter introduces a number of further techniques that will lift your paintings well above average. Some are simple, while others need a little practice. Many of these techniques can be found in illustrations scattered throughout the book, in addition to the specific examples shown here. Some are designed to give your painting more power, while others are excellent strategies for improving a painting that has become a little wayward. Take care, however, not to attempt to include all the techniques in the same painting, as it may then start to look contrived.

Softening Edges

One fascinating but simple technique is to soften off certain edges of a feature with a damp brush immediately it has been painted, as any delay can cause unsightly backruns to form. This can work well with cloud shapes, hedgerows, rocks, buildings, and all kinds of objects. Rocks, for example, usually offer hard edges, but where they stand in the earth, grass or water, they are more likely to have softer, less well-defined edges. If they reveal hard

edges all round they look as though they have been cut out by a knife and stuck on to the paper, rather like a chestnut sitting on a white tablecloth. At times, it can help to deliberately lose hard edges that are actually present in the scene.

Lost-and-found Detail

This technique is especially effective where monotonous repetition of detail occurs. Large areas of brickwork, stones in a drystone wall, massed trees, long foreground hedgerows, pebbles on a beach, hosts of flowers and many similarly detailed objects can create boring passages. The answer is to define a limited number of these and let the eye of the beholder fill in the rest. Pick out the most handsome examples for inclusion, or include only

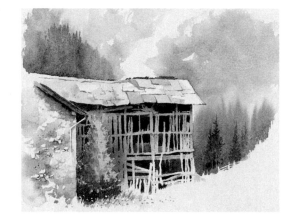

▶ DOUGLAS HARBOUR, ISLE OF MAN
288 x 355 mm (11 x 14 in)
The old tug has been accentuated as the centre of interest by applying strong tones, to contrast with the deliberately softened background immediately surrounding it. This also suggests a sense of distance beyond the vessel. Dragging almost dry paint across the foreground creates sparkle in the water, made more effective by using Saunders Waterford Rough paper. By limiting the number of colours, a sense of atmosphere prevails over this lovely old harbour.

◀ RUSTIC ALPINE DWELLING
180 x 200 mm (7 x 8 in)
A vignette done on Bockingford cream-tinted paper. Tinted papers are ideal for vignettes, as they encourage artists to be less inhibited in leaving bare paper than when using white. The tree mass to the right was created using the wet-in-wet method, which is extremely effective when set against a feature as strongly etched as this building. I have made extensive use of the negative painting method, illustrating the wooden structure by painting the dark interior gaps.

those in the optimum positions, such as the capstones and stones adjacent to a gate in a drystone wall, the corner bricks or stones in a building, or the parapet and arch detail of a bridge.

One technique that can prove useful with the lost-and-found method is to apply slightly more detail than desired, and then to lose the edges of that detail with a brush while it is still wet. This gives a natural feeling of gradually losing the feature. Another way is to employ the vignette approach, where the detail can be completely lost towards the extremities of the composition. Sometimes the lack of detail in a large passage can appear rather stark, and it can be helpful to drop stronger colour into a wet area, to create a soft transition.

Abstraction

A further method of losing unnecessary detail and enhancing the interest of a passage is by making it abstract. Here, you can let your imagination run free, laying on colours and shapes in sympathy with the subject, and in particular with that part of the scene. If, for example, you decide to abstract the foreground which comprises a mixture of rocks, bushes, roots and earth, aim to suggest an abstract pattern based on these shapes. Erosion on riverbanks can reveal stones and earth caught up within the intricacy of tree roots, which forms a fascinating pattern of shapes and colours. Alternatively, the abstract passage might be based on man-made features such as harbour walls, oil

drums, agricultural implements or buildings, perhaps painted with more regular outlines.

You can begin abstraction by laying on washes with two or three contrasting colours, allowing them to run into one another and perhaps drawing into them with a fine brush, or pulling out colour in

▲ Cottage with abstract foreground
The techniques in this sketch can be the answer to all sorts of awkward foregrounds, as you can drop in colours and draw shapes with a fine brush. Blotters, tissues, masking fluid, salt, spray, and all manner of devices can be used to create effects. Practise on scrap paper first, or perhaps on a painting that has gone wayward.

places with a tissue while the paper is still wet. This can often suggest shapes, or you can follow the general pattern of the features. When the wash has dried, further drawing over it with a brush will accentuate the shapes. Sponges, masking fluid, tissues, spray bottles and blotting paper can be used to create interesting effects at various stages of drying, as well as techniques such as spattering. In addition to the technical possibilities, abstraction can be truly imaginative, and helps you to loosen up.

Painting Negative Shapes

Many artists rely solely on masking fluid to create light-coloured detail against a darker detail. While masking fluid is an excellent tool, there are times when it is more effective to actually paint the dark areas around the light detail – negative painting. In addition, some papers are prone to tearing when the fluid is removed, and even though I use a fairly robust paper I still prefer the technique of negative painting. Masking fluid can also remove any paint underneath when it is rubbed off.

As with most watercolour applications, when painting negative shapes work from light to dark, making sure each wash is dry before applying the next. It is a good idea to define intricate details carefully with a pencil before beginning to apply the paint. If you are new to this technique, try simple shapes on scrap paper first, and once you have gained some experience – and it is enjoyable practice – use it in a painting.

▼ COTTAGE NEAR KILMUIR, ISLE OF SKYE
230 x 305 mm (9 x 12 in)
This painting brings together many of the points covered in the foregoing chapters, illustrating how you can add power to your work.

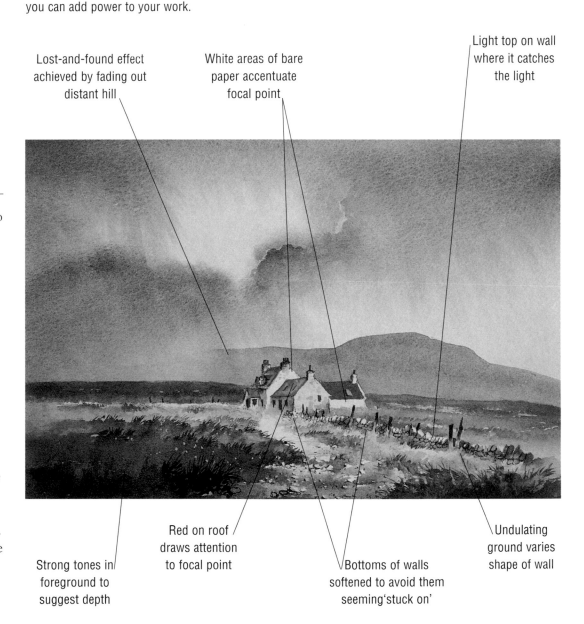

Lost-and-found effect achieved by fading out distant hill

White areas of bare paper accentuate focal point

Light top on wall where it catches the light

Strong tones in foreground to suggest depth

Red on roof draws attention to focal point

Bottoms of walls softened to avoid them seeming 'stuck on'

Undulating ground varies shape of wall

Demonstration

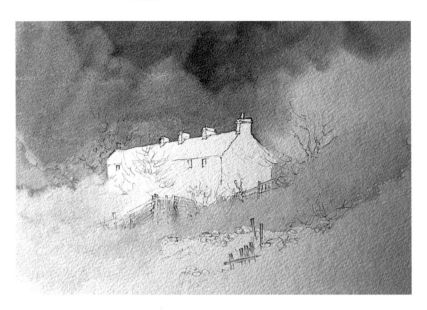

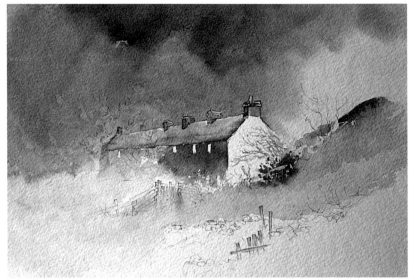

▲ Stage 2

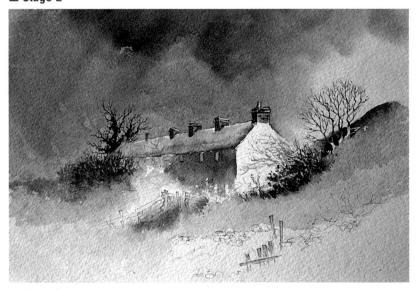

▲ Stage 3

COTTAGE ROW,
GELLIFELEN
215 x 293 mm
(8½ x 11½ in)

Although some artists rely solely on masking fluid to create light-coloured detail against a darker background, there are times when it is more effective to actually paint the dark areas around the light detail – negative painting. Masking fluid can tear some papers,

and can also remove any paint underneath when it is rubbed off. As with most water-colour applications, work from light to dark, making sure the wash is absolutely dry before applying the next. Where there will be intricate detail, it pays to define this carefully with a pencil beforehand.

▲ Stage 1
Masking fluid was first brushed on to the near posts and pig wire beside the gable end, and was allowed to dry. Naples Yellow was applied to the right-hand sky area where the tree would appear. The rest of the sky was painted with a mixture of Monestial Blue and Cadmium Red, and a wash of Raw Sienna was then brushed on lower down.

Stage 2

More Cadmium Red was introduced into the mixture, with Monestial Blue for the roof, and some darks were added to the right-hand side. The front wall and chimneys were painted with Monestial Blue and Burnt Sienna, with Raw Sienna dropped into the wet wash in places, allowing it to drift into the original wash. Monestial Blue with a touch of Cadmium Red formed the mix for the cast shadows on the white gable end.

Stage 3

A No. 4 brush was used to paint in the tree at the far end and some right-hand details, using Monestial Blue and Burnt Sienna. A mixture of Monestial Blue and Light Red was then scratched on with the side of the brush, to suggest the vegetation in front of the left-hand end of the cottages.

▶ Detail of gate and bush from Stage 4

Painting the gate by the negative method rather than with masking fluid made it possible to lay down the various colours before applying the darks. Using masking fluid would have resulted in a stark white image, into which the various subsequent colours would have had to be painstakingly painted.

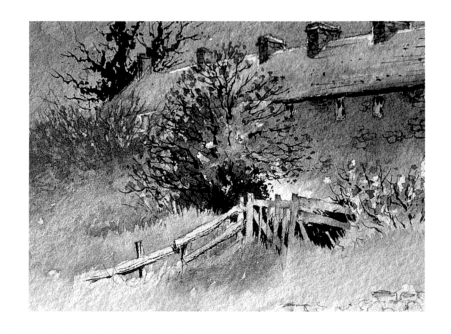

◀ Stage 4

The masking fluid was removed from the fence by the gable end, and the bushes and undergrowth were then worked on. A strong combination of Monestial Blue and Burnt Sienna rendered details on the buildings and gate. The work was completed with detail added to the fence and bushes and a wash of Monestial Blue and Burnt Sienna laid across the foreground. Finally, the immediate foreground detail was added.

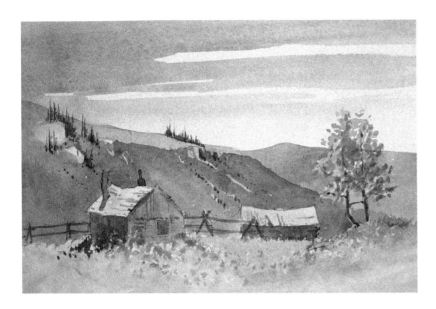 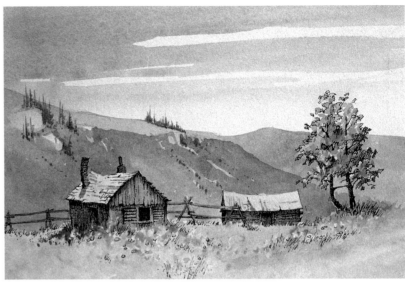

Pen and Wash

Another method of improving a water-colour that is lacking in strong tones is that of drawing into it with a pen. It is certainly worth trying to strengthen a painting in this way, although if your work lacks tone regularly, you would probably benefit from carrying out a few monochrome paintings, using a dark colour such as Payne's Grey or Burnt Umber, to improve your understanding of tonal values.

However, it would be wrong to think of pen and wash purely as a rescue medium for paintings that do not come up to scratch, as it is a marvellous technique in its own right. Some artists, especially those who enjoy drawing, find that it suits their style better than pure watercolour. It can be employed for both sketches and finished watercolours.

There are two basic methods of working. First, the wash can be laid loosely to provide the shapes of the subject, and the ink can then be applied once the washes have dried. The second approach involves sketching in ink first, and then applying colour. In either case, the preliminary work can be done with a pencil, although you can dive straight in with the pen.

The phrase 'pen and wash' tends to be taken as describing a style of loose washes of weak tones that then uses the pen line to define objects, although there is no reason why you should not use strong tones in places. Another approach is to work in darker tones by crosshatching with the pen. To create a sense of distance on hills and other objects, it is best to rely on the wash itself if you can, as pen line tends to bring features forward, thus destroying the sense of depth.

▲ MINERS' DELIGHT GHOST TOWN, WYOMING (above left)
180 x 240 mm (7 x 9½ in)
The technique of adding penwork to a watercolour can be effective in its own right, as well as a means of rescuing a watercolour that lacks tonal strength. Here I have used HP paper, as the pen responds better on a smooth surface. Because the washes have been applied with little regard to tonal variation, the picture lacks impact and is destined for the rubbish bin.

Penwork added (above)
Using a technical pen that is designed to avoid scratching when working at an angle to the paper, I have both drawn in the outlines and applied dark hatching to create dark tones. Note how the distant hills are devoid of penwork, to allow the hills to recede – strong line will bring them forward. Watch this effect also in sky areas. The penwork can be applied first, of course, if you prefer.

Giving Punch to a Tired Painting

Paintings often fall short of the artist's hopes and expectations. However, this may only be a minor problem that can be easily rectified. When a painting seems to have lost its way, put it away for a while, then look at it afresh.

Watercolours can be improved in a number of subtle ways. Gentle sponging can subdue or remove passages that have not worked. A glaze of weak colour across an area can unify that part of the picture and create a sense of atmosphere. Spatter can beef up a foreground without making it appear too busy. Perhaps the composition is lacking in strong tones, especially around the focal point; this can be dramatically improved by introducing more powerful tones and colours. If the painting has really flopped, you have nothing to lose by sticking it in the bath and hosing it down. Once it has dried, see if any or all of it can be saved.

Exercises

Many scenes contain exciting elements, but do not work as a whole. With a little ingenuity the picture can be transformed totally, by emphasizing those elements that attracted you, and by subduing those that did not. Consider this possibility when attempting the Medicine Bow and Lakeland scenes in this chapter.

Exercises

◀ With so many trees and bits of rock, this lakeside scene in the Medicine Bow Mountains is something of a challenge. How do you manage that background? Work out a suitable focal point, and perhaps introduce some atmosphere and light into the scene. My interpretation is on page 125.

▼ You may wish to extend the landscape on either side, but without reference, how can you achieve a convincing effect? You could give the mountains more prominence by reducing the height of the tree. What about the fence in the foreground, erected with total disregard for the rules of composition? My version of the subject is on page 126.

Progressing your Work

Keeping the momentum of your painting going is not always easy – 'What do I paint next?' is the anguished cry, and every artist wishes he or she had more ideas. This section looks at ways of making your painting schedules more exciting. Continuing the progress of your work is essential, so here we will examine ideas and projects which will keep improving the quality of your watercolours through a planned programme. From there, it is a logical progression to take a look at exhibiting, showing you how to begin in a small way until you feel confident enough to put on a full exhibition. Organizing your work along the lines outlined here can be another potent tool in developing your watercolours.

▶ EVENING, RIVER DEBEN, SUFFOLK
230 x 330 mm (9 x 13 in)
My aim with this painting was to put across the feeling of a tranquil evening. A jetty stood to the right, and although I had included it in a sketch, I decided to leave it out here as being intrusive. The small rivulet in the foreground acts as a lead-in, a useful device when a feature such as a river or lake lies across the composition.

10 Projects and Exhibitions

For your painting to progress it is important to plan ahead. Painting with an objective in mind will give your work a sense of purpose and prevent you from becoming stale. This chapter outlines a number of possible programmes based on a project approach, which will probably trigger other ideas. This will not only offer you a goal to aim at, but will also ensure that you keep your watercolours developing and improving.

I find it essential to plan a series of paintings well in advance of target dates, as so many things can happen to throw the schedule out of gear. Whether it is an 80-picture solo exhibition or a handful of paintings in a mixed exhibition, careful consideration is needed to ensure the right mix is included. Should the exhibition have a theme? If so, what? Will the venue expect paintings of subjects local to their area? What mixture of sizes will work best? Are foreign scenes acceptable?

Types of Project

When you consider what sort of project to work on, bear in mind your favourite types of subject or location, or perhaps think about relating it to one of your non-artistic interests. You are much more likely to do a better job of a type of subject that appeals to you. The Suggested Projects Checklist on page 108 is a drop in the ocean, but it will give you some ideas and should generate others.

Planning the Project

Once an idea strikes you, the first point to consider is its feasibility. Suppose you decide on a bridges theme, perhaps because you are aware of two or three picturesque ones nearby. Can you then find enough bridges to fill the exhibition or display? Will the exhibition cover bridges in the city, locally, the county, the region, or perhaps along one river only? Maybe some bridges are good enough to paint from two different angles. Would some look better under snow or at a certain time of year?

I always put these considerations and ideas down on paper, and before making a final decision I go out on-site to check that there is likely to be sufficient material available. If the project seems possible you need to think about its appeal, and this is often best discussed with others, such as gallery owners and interested parties, particularly if you are intending to work with charities or other organizations. Working to a theme in this manner will certainly afford you a better chance of gaining publicity, as well as giving your work a fresh approach.

▶ RIVER BRATHAY, CUMBRIA
200 x 305 mm (8 x 12 in)
With a project such as rivers, the scenery obviously includes many other features, but all the paintings could be held together with the river theme.

SUGGESTED PROJECTS
Checklist

✓ **Holidays**
✓ **Local industry**
✓ **Farming**
✓ **Churches**
✓ **Castles**
✓ **Bridges**
✓ **Public houses**
✓ **Rivers**
✓ **Seaside and marine**
✓ **Gardens**
✓ **Ancient buildings**
✓ **Villages**
✓ **Lakes**
✓ **Mountains**

Holiday Projects

Planning a holiday project can be great fun, contributing an extra ingredient to your vacation. Whether you wish to work to a particular theme or generally cover as many aspects of your holiday destination as possible, advance research will help enormously in locating the best subjects. This is particularly the case if you are going abroad, where the different culture itself might provide ample material. In seeking out the large vistas and panoramas do not forget the quiet corners, studies and more intimate objects.

▼ Cottages at Crowland, Lincolnshire
This sketch was done with a Derwent terracotta pencil. I loved the absolute wonkiness of the main cottage, and to accentuate this described the further buildings in silhouette. I would add figures in a painting of such a scene.

Reconstruction Painting

Many people enjoy painting bygone scenes, from galleons, steam trains, old coal mines and thatched dwellings, to long-defunct farm implements and the like. Many such scenes can be re-created in an authentic way. When I worked on my book, *Images of the South Wales Mines*, a number of the paintings were created

from long-lost scenes. Mining museums provided a wealth of material. In one case the blacksmith's shop – a vital part of the mine – looked distinctly sad without a roaring fire and working blacksmith. The answer was to sketch a blacksmith working elsewhere and introduce him into the required location, taking care with the lighting, of course.

Seeking out museums is half the fun. Try country shows or working museums, where you may well see the subjects in action. Sketching people in period costume carrying out appropriate actions is far better than trying to work from old photographs. Reconstructing scenes in this way can be a rewarding aspect of painting, bringing to life scenes that have totally disappeared from our lives.

'Green' Paintings

Any landscape artist who regularly sketches and paints in the countryside will soon become aware that in many areas the landscape is gradually changing – not usually for the better. There are countless examples: new roads cut through great chunks of greenery; quarries gouge vast holes in prime landscape; open-cast mining can leave a landscape looking like a First World War battlefield; and ugly developments encroach upon the countryside everywhere. Many subjects of great value are thus being lost: decrepit, tumbledown old barns that make wonderful subjects are being turned into modern dwellings, ancient stone bridges are being demolished, farms are being

modernized with unsightly new construction, and so on.

If we value the countryside, we need to be alive to these problems, and as an artist dependent on the beauty of the country-side for my living, I feel strongly that I should put something back into the land-scape. Obviously there has to be change, but it must be for the better. For instance, you may well have sketched or photo-graphed many lovely old barns over the years, so why not do a survey of those in

▲ Barns in the Vallée de Louron, Pyrenees
A holiday project can cover all sorts of subjects, or you may prefer to concentrate on one theme, such as sketches of mountains or buildings.

your area? Paint the remaining ones, and add in those that you already have sketch material on, even if they have disappeared. Your barn series can then highlight both the glory and beauty of these buildings and the sad loss as they are converted or fall into disrepair.

A Reconstruction Project

This project is an in-depth look at re-creating a scene from the past without resorting to copying old photographs. Big Pit is a coal-mining museum at Blaenafon in south-east Wales, where you can drop over 90 m (300 ft) underground to see what it was like to work in a mine. Nearby is a steam railway normally operated at weekends by enthusiasts. This combination of railway and mine excited me. The question was, how could I recapture a flavour of the past at Big Pit during the heyday of steam?

The existing steam railway is too far away from the pithead for my purposes, but I began to piece things together slowly and I located the old railway line fairly easily. These days the ground around Big Pit is green: clearly, to look as if the mine is in use it needs more muck than grass. From the old photographs I had seen, the whole layout has changed considerably, spoil heaps have been flattened, and much detritus cleared away.

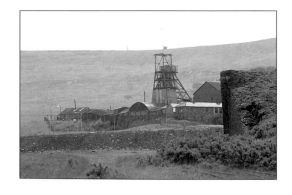

▲ **Big Pit from the old railway**

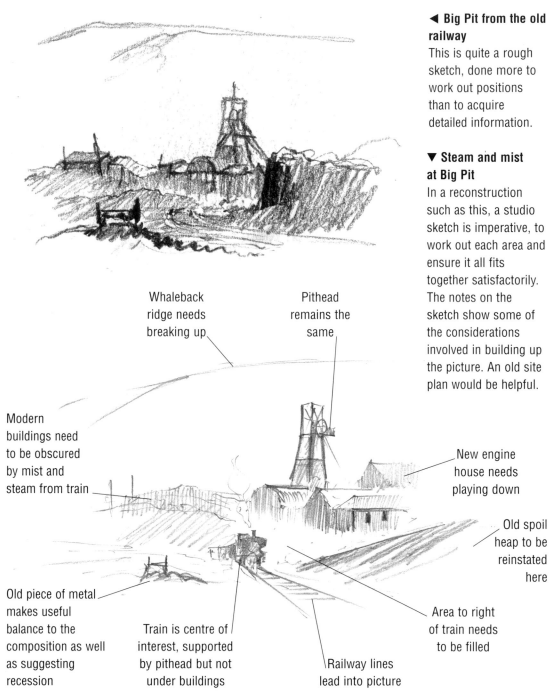

◄ **Big Pit from the old railway**
This is quite a rough sketch, done more to work out positions than to acquire detailed information.

▼ **Steam and mist at Big Pit**
In a reconstruction such as this, a studio sketch is imperative, to work out each area and ensure it all fits together satisfactorily. The notes on the sketch show some of the considerations involved in building up the picture. An old site plan would be helpful.

Whaleback ridge needs breaking up

Pithead remains the same

Modern buildings need to be obscured by mist and steam from train

New engine house needs playing down

Old spoil heap to be reinstated here

Old piece of metal makes useful balance to the composition as well as suggesting recession

Train is centre of interest, supported by pithead but not under buildings

Railway lines lead into picture

Area to right of train needs to be filled

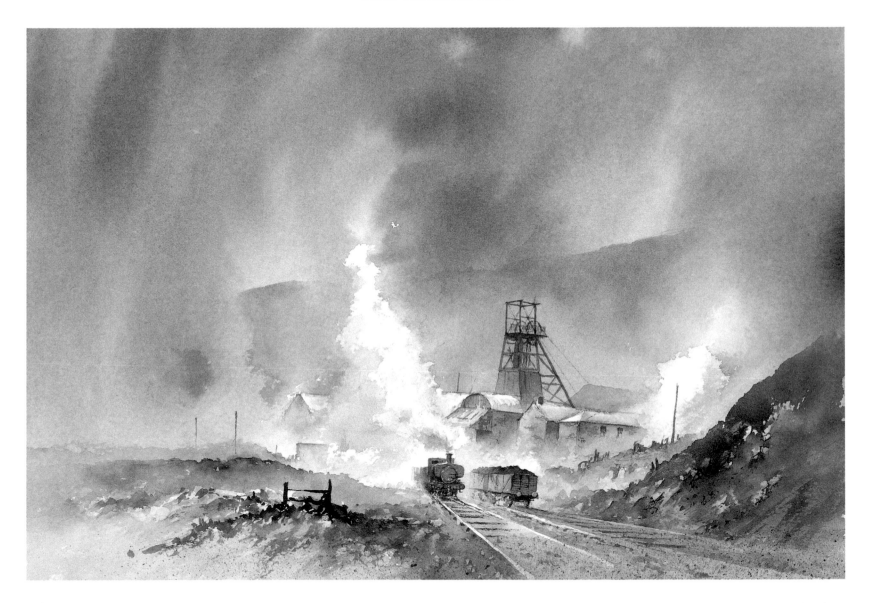

▲ STEAM AND MIST AT BIG PIT, BLAENAFON
230 x 330 mm (9 x 13 in)
Steam and mist have a marvellous way of blocking out parts that you are unsure about, and in this example I have used them to the full. The area immediately to the right of the locomotive bothered me, as something had to go there, and I was unsure how that area would have appeared in the past. My answer was to place coal wagons next to the engine.

Locomotives need to be the type that worked on the line, but once you know this, railway preservation centres are the next stop, to sketch the exact locomotives and wagons. You could, of course, use model railways if you were really stuck. I created balance on the left-hand side by including a dark-coloured piece of equipment resembling a stile.

111

An Environmental Project

I have been involved in several environmental campaigns, mainly to highlight the beauty of a threatened location. Artists are particularly well equipped to help in this way. Some of my paintings have been used to gain attention to many causes: the potential loss of mature trees; the roofing over of part of a gorge and a river being culverted in places; great cantilevered concrete sections destroying natural beauty; the demolition of a sixteenth-century pub; and the loss of habitats and footpaths.

The paintings on these pages have appeared in exhibitions that Jenny Keal and I have put on to increase awareness of the Clydach Gorge, an amazing place which lies within the Brecon Beacons National Park in Wales. They have been used in articles both locally and nation-wide, as well as a number of television programmes. The media has been especially helpful in putting across our message, and the exhibitions have been well attended. When people feel they are about to lose something, they will often act more readily. Using paintings in this way can help the countryside, as well as giving your work tremendous publicity.

◀ COTTAGES AT CLYDACH
230 x 330 mm
(9 x 13 in)
Many cottages cling to the sides of the gorge, with a beauty of their own. Sadly, some of these may well disappear if a road is driven through.

▲ WATERFALL IN THE CLYDACH GORGE
485 x 623 mm (19 x 24½ in)
Misty days are excellent times for sketching in a gorge, as so much of the detail is reduced. There are countless waterfalls and cascades in the Clydach Gorge as the river tumbles down a rocky staircase, making it a treasure-house for artists and ramblers. The aim of this painting was to illustrate the beauty of the gorge, to show why it should be preserved, and to argue that culverting the river and roofing it over with cantilevered concrete supports would not enhance its beauty.

▲ EVENING LIGHT, CLYDACH GORGE
200 x 280 mm (8 x 11 in)
The mature trees in the centre of this watercolour
may disappear if a road scheme goes ahead. Right
in the heart of the gorge, they form a lovely
grouping, especially glorious in winter.

Wildlife

The landscape, of course, provides the habitats for wildlife, and even if you do not paint animals or birds, your project could benefit enormously from allying yourself with wildlife organizations. Some of these groups have facilities for producing posters and publicity brochures, and can provide literature, information, photographs and all manner of assistance to your project, once they know your interest is serious.

Working with Charities

Running an exhibition or display in conjunction with charities can be of enormous benefit to both the charity and yourself, as both parties may achieve good publicity and financial reward. Local newspapers are usually only too keen on such events, so it is worth getting to know your local charity organisers and reporters. Working with health-related organisations and similar charities can be satisfying, but do not forget those that are connected to the countryside or ancient buildings, with which it is easy to identify your particular subjects and themes.

Working Towards an Exhibition

Putting on a one-person exhibition of reasonable size is no small undertaking, and it is sensible to test the water first in a smaller way. Exhibiting two or three paintings at an art society function or a local open exhibition allows you to see

how your work compares when hung with that of others. Taking your turn at invigilating the exhibition will give you experience in talking to the buying public, learning about the art of selling paintings, and what customers want. You may not wish to do the actual selling, but you will learn a lot by doing so.

Not everyone, however, has an art society or open art show in their area, and to show your work to the public at large, you may need to organize your own event. There are many opportunities for doing this, for example by displaying a few paintings in the local library, theatre foyer or restaurant, or in shop windows, preferably where passers-by will see the

▲ GATHERING THE STRAYS
230 x 318 mm (9 x 12½ in)
It is worth including a few works featuring animals or figures in an exhibition of landscape paintings, to add variety to your display.

paintings. You will often find that people are happy for you to come along and brighten up their walls, and you will not always be charged commission. Some traders and retailers will not take charge of responsibility for the actual selling, though, and will simply pass on the names of the potential buyers.

▲ PENNINE FARM
305 x 485 mm (12 x 19 in)
Here the sky above the farm has been emphasized to support the focal point.

VENUE
Checklist

✓ Is there sufficient hanging space?

✓ Is the lighting adequate?

✓ Can you knock nails into the wall, or is there an alternative system for hanging?

✓ Is the room reasonably secure, or are there too many entrances for adequate control?

✓ Can you display signs outside the room?

✓ Is a telephone essential?

✓ Are there toilet and washing facilities?

✓ Can you make tea and coffee?

✓ How much will the hire of the room cost, or will arrangements be on a commission basis?

✓ Does the venue do any publicity?

✓ Will you have to invigilate?

Organizing Your Own Exhibition

Exhibiting with others and setting up your own displays will help you to gauge the response to your work. Only when you have begun to sell reasonably well should you think about undertaking a full exhibition, as the cost in framing alone is heavy. Unless you have made meteoric progress, you are unlikely to be invited to exhibit by a gallery until you are better known, so the only way forward may be to set up your own exhibition or invite artist friends to join you in doing so.

Among the possible venues are village halls, hotel conference rooms, libraries, schools and colleges; visit a number of places before committing yourself. Draw up a list of requirements for the venue, so that when you make your visit you can instantly see if it will suit your needs. Points to consider are listed in the Venue Checklist on the left.

Planning the Exhibition

How many paintings can you fit into the venue, and how can you best display them? The mixture of sizes is important, as having all your paintings the same size can look monotonous. One or two large works help to create a focal point to a display of paintings arranged along a wall, and a few small ones not only break up the monotony, but satisfy those who cannot afford the larger ones. The Exhibition Checklist on the right contains the basic considerations, and you will add to them from your own experience.

EXHIBITION
Checklist

✓ Set targets of number and sizes of paintings

✓ Draw up a time schedule to allow for possible problems

✓ Prepare a catalogue or list of paintings

✓ Write out labels, perhaps with captions

✓ Prepare copies of a short CV on yourself

✓ Prepare posters, invitations and leaflets

✓ Arrange any advertising

✓ Send out press releases to local press

✓ Arrange for someone to open the exhibition

✓ Provide wine and glasses for the private view

Framing

I have never attempted to do my own framing, firmly believing that to be done properly, it needs to be carried out by an expert. If you do not wish to try your hand at framing, it is worth seeking out a framer to suit your needs. A commercial framer will have many overheads and be more expensive than the part-timer; if you find a part-timer, then look at examples of his or her work. Some local artists and members of art societies will frame pictures for others at a reasonable price – do be aware, though, that good presentation is vital, and it is foolish to exhibit your paintings in shoddy frames.

Approaching a Gallery

Once you have a track record, it can be worth approaching a commercial gallery, but this needs preparation. I blithely ignored galleries until one approached me, so it is often not easy to tell when to strike. Keep a number of earlier exhibition brochures or leaflets, as these give a good idea of what you have done, so long as your work is acceptable. Before approaching a gallery directly, visit a number incognito, to see what type of work they show. If you like the place and the staff seem friendly enough, put it on a list of possibilities.

Once you have chosen a gallery to approach, telephone and ask for an appointment to bring along some of your originals. They may wish to see photographs or transparencies first, so

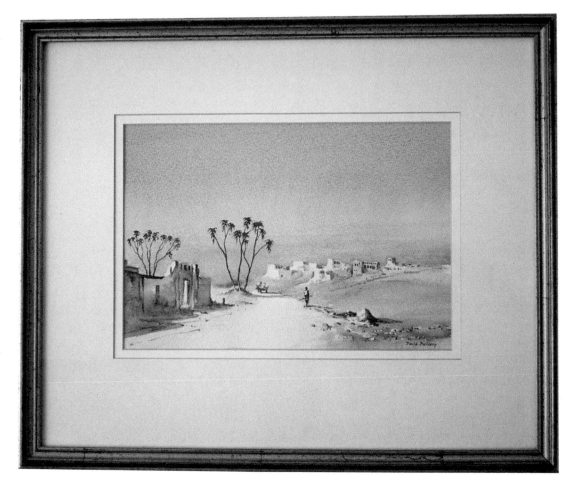

ensure that you record your paintings in this way. Take along only your best work, and under no circumstances include any copies of work by other artists, as this can be spotted a mile away by a gallery owner.

Learning Through Exhibitions

Exhibiting your work is both rewarding and exciting. I know people who never exhibit, despite producing marvellous work, and others who cannot paint terribly

▲ **Presentation**
Good presentation is vital. I prefer to use a double mount, usually with a white inner and ivory outer, which gives a sense of unity to a display.

well, but who enjoy the thrill of the exhibition. I only wish I had the time to visit more exhibitions – it goes without saying that if you wish to exhibit your own paintings you should avidly seek out and learn from those of other artists, as well as looking at how the works were shown.

Gallery of Paintings

This final section shows my 'answers' to the exercises set at the end of earlier chapters. Each exercise puts across a particular lesson, which is given prominence in the 'answer', but of course many of the problems encountered within the paintings overlap, and so you will find similar problems tackled in different ways throughout this section. If I were to repeat the exercises myself, each result would be different. When I find a superb subject I re-paint it, sometimes a number of times, perhaps depicting a different season, a new angle, a different mood, adding in figures, animals or other appropriate features, or omitting items and vignetting the foreground. Using combinations of the exercises in this book, you can repeat a scene and produce a completely different result. Your approach will be as valid as mine – and you can always repeat the painting!

▶ GARBOLDISHAM, NORFOLK
200 x 330 mm (8 x 13 in)
I have kept my version of this scene fairly simple. The trunk road has been reduced to a cart track, on which I have left white paper where the light catches the rise in the track. The painting is reasonably faithful to the original sketch.

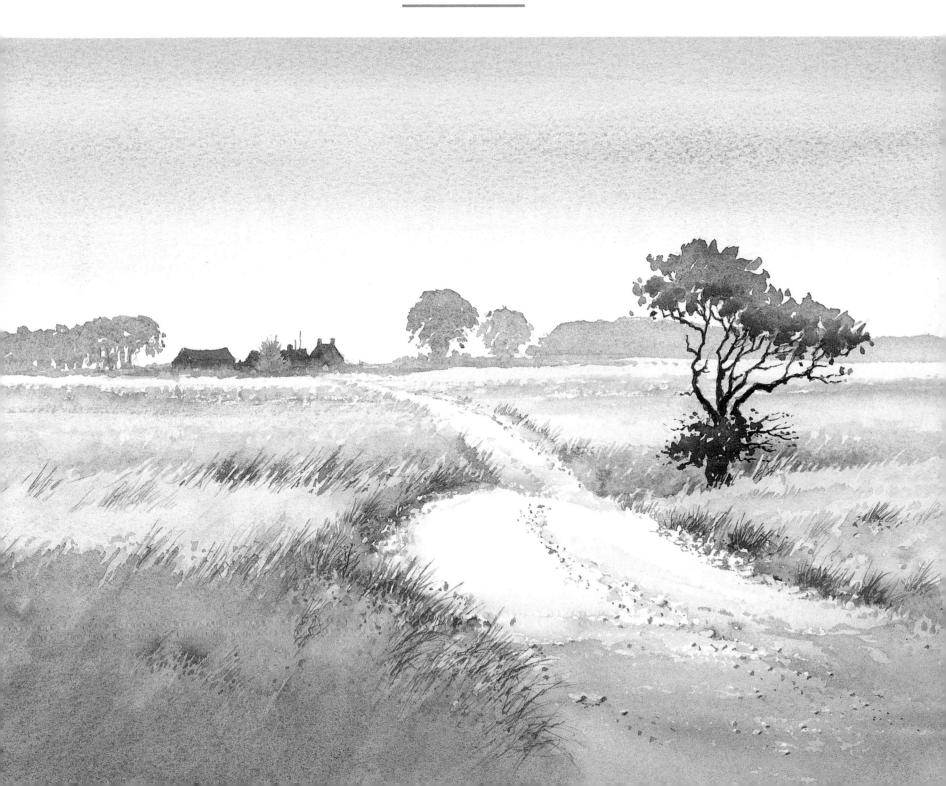

► BRIDGE NEAR KILLARY HARBOUR
200 x 305 mm (8 x 12 in)
Again, this painting follows the original scene closely, though reducing the central band of bushes to a mere suggestion. The distant Twelve Bens have been kept as a flat wash, for which I used Indigo, as with the sky. A trickle of water emerges from under the bridge, which adds both interest and a lead-in to the focal point.

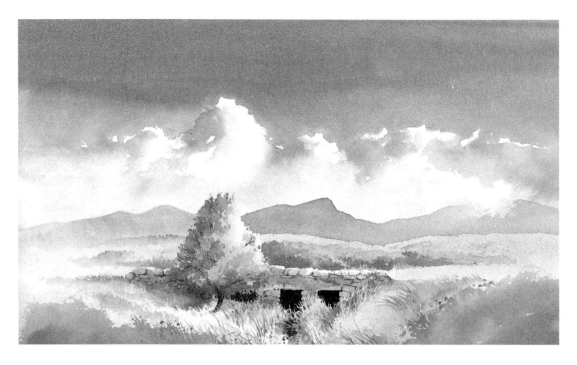

◄ BARN IN THE PYRENEES
230 x 305 mm (9 x 12 in)
The background has been kept simple, to avoid competition with the foreground. A gap in the undergrowth has deliberately been left to lead the eye up to the focal point, and the flowers pushed mainly over to the right. Masking fluid was used for the white flowers. I liked the way that the foliage from the left-hand tree broke up the hard lines of the barn in places.

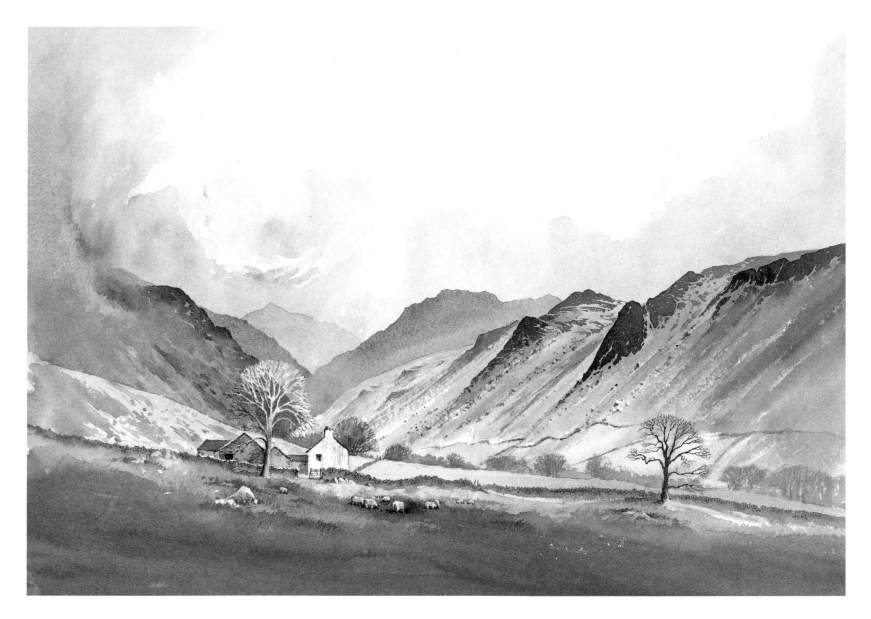

▲ FARM IN UPPER ESKDALE, CUMBRIA
330 x 485 mm (13 x 19 in)
The first thing I did was to move the large tree quite some way to the right. Some of the right-hand slopes went over the top of the building, so I adjusted them to run down towards the farm, a useful compositional device to further emphasize the centre of interest. I then added some sheep, to complete the compositional changes. Masking fluid was used on the tree next to the farm, but this had to be slightly rectified with a No. 4 sable when the fluid was removed, as it does not work so well on such fine detail.

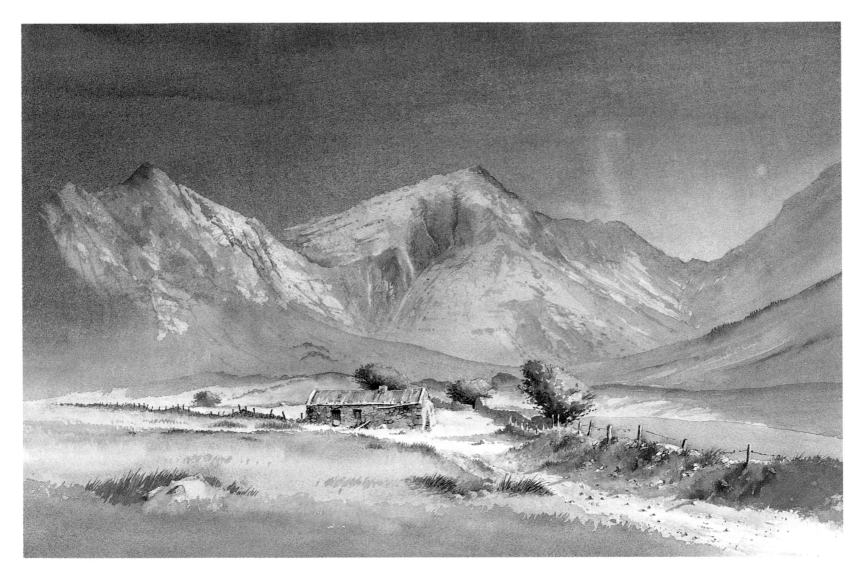

▲ BARN IN GLEN INAGH, CONNEMARA
280 x 430 mm (11 x 17 in)
In this painting, I wanted to create a dull
background to contrast with a sunlit foreground.
I was tempted to do a close-up of the barn with
all its wonderful detail, but I shall leave that for
another time.

► CASCADE, RIVER CLYDACH, GWENT
200 x 305 mm (8 x 12 in)
I have adopted the wet-in-wet system in the background, using Naples Yellow in the central area, with French Ultramarine and Cadmium Red providing a warm grey to suggest a mass of trees. Closer in, I have reduced the number of trees and kept the far bank in shadow, to allow the cascade itself to remain the highlight.

◄ ELTERWATER AND THE LANGDALE PIKES
230 x 330 mm (9 x 13 in)
I kept the mountains as a flat wash, losing some of the strength to the right. The technique of graduating the wash so that it becomes lighter lower down the mountain helps to suggest depth with each ridge as they successively overlap. Reducing the amount of trees on the nearest ridge, I accentuated those close to the gap created to the left of centre. This aids in drawing the eye, together with a splash of Cadmium Yellow on the bank beneath the gap. With the reflections, my priority was to keep them simple and drop the tree reflections into the wet lake area. Finally, I felt the subject needed more of a sense of depth, so I added some reeds and a rotting branch in the right foreground to achieve this.

▶ SOUK IN MARRAKESH, MOROCCO
165 x 230 mm (6½ x 9 in)

With all the figures, this is perhaps not the easiest exercise. I left out many figures and orientalized others. All the background details took some time to render, with the splashes of colour most important. When all that was thoroughly dry, I laid a glaze of French Ultramarine and Crimson Alizarin across the whole of the background, except for the hanging garments. This brought all the disparate elements in the distance together, and allowed more emphasis on the sunlit part of the work.

The bicycle and fruit-cart were important elements, which I accentuated in strength as the centre of interest. To the left, the watercolourist's nightmare of shiny brass ornaments hanging in wild profusion was played down. To complete the painting, I used the silhouette method for framing the scene. This added depth effectively, without distracting from the focal point of the painting.

◀ AUTUMN WOODLAND
180 x 255 mm (7 x 10 in)

After the hubbub of Marrakesh, this subject comes as welcome relief to the landscape artist. Like me, were you tempted to put in every tree shown in the photograph? The small tree on the right neatly balances the composition. Any larger, and it would compete with the centre of interest. You might have substituted the sheep with squirrels.

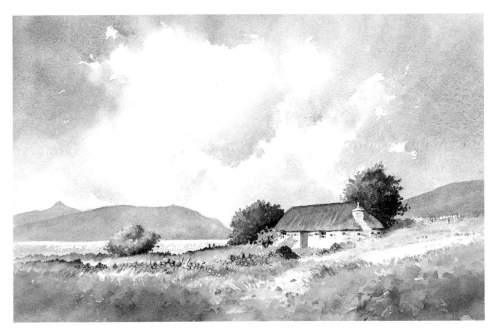

▼ LAKE MARIE, MEDICINE BOW MOUNTAINS
305 x 230 mm (12 x 9 in)
Although this hardly resembles the original scene,
by moving the foreground trees to the left and
bringing down the mist, it is still Lake Marie.

▲ COTTAGE, ISLE OF SKYE
215 x 330 mm (8½ x 13 in)
I did not want to include the house at the rear, and
I have varied the trees in size and position – they
were just a little too regular. Note the
counterchange on the thatch and drystone walls,
and the sense of sunlight caused by the cast
shadow of the little sapling in front of the cottage.
For extra colour I have included some flowers
along the closer wall.

▲ FARM AT OLD DUNGEON GHYLL, LAKE DISTRICT
280 x 355 mm (11 x 14 in)
I felt the picture benefited enormously from being pushed back, to give the buildings more breathing space. Darkening the gable end of the house makes it appear more solid, as well as helping to accentuate the white muck spreader, or whatever the machine is behind the tractor. More red on the tractor adds welcome colour, and the chickens introduce life. Lowering the tree gives more emphasis to the mountain, and I decided to bulldoze the fence completely out of the picture.

This is the sort of subject that you can repeat in a variety of ways: leaving out the snow, including figures, bringing rain down over the mountain or perhaps changing the tractor for a combine harvester. Have a go at these scenes with different approaches, but most of all, enjoy your painting!

Index

Index